The

Confident Creative

Published in 2010 by Findhorn Press, Scotland

ISBN 978-1-84409-185-0

Credits: see page 126.

Printed and bound in China

1 2 3 4 5 6 7 8 9 10 11 12 13 14 15 14 13 12 11 10

Published by
Findhorn Press
305a The Park, Findhorn
Forres IV36 3TE, Scotland, UK
t +44-(0)1309-690582
f +44-(0)131-777-2177
e info@findhornpress.com
www.findhornpress.com

The

Confident Creative

· · · · ·

Drawing to Free the Hand *and* Mind

Cat Bennett

FINDHORN PRESS

"Ring the bells that still can ring,
Forget your perfect offering,
There's a crack in everything.
That's how the light gets in."
—Leonard Cohen

Contents

Preface

What does it mean to be creative? And why do so many of us feel blocked in some way or other? To be creative is to make something new or to make new connections between ideas that already exist. Most of us know this, but do we know that we are all essentially creative beings? It's not just art that requires creativity; we're inventing our very lives all the time through our intentions and actions. Still, many of us feel we're not creative though we might long to be. We've stopped envisioning expansive possibility and started settling for half-measures.

In the same way, many of us feel we can't draw even though as children we did. We feel the simple, basic, even inherent quality of making marks on a surface is beyond us. There are many ways to draw as we'll see—making marks, drawing from life and drawing from imagination. It's a myth that special talent is needed. We often think the purpose of drawing is to produce an image or likeness but it holds the potential to do much more. The simple act of drawing can deepen our sense of presence and open the gates to creativity. This is a new kind of drawing, not the kind we learned in school!

By its very nature, drawing takes us out of our worrying minds and into the wide open space of peace and possibility where inspiration comes to meet us. Artists will benefit from a drawing practice, of course. But writers, musicians, dancers, filmmakers, gardeners, cooks, scientists, designers, craftspeople, and all who wish to live authentic, exploratory, creative lives will find the practice both liberating and empowering.

Most people give up drawing in childhood when they fail to make drawings that look "real." Some of us may also give up some essential part of ourselves when we stop drawing. We may lose touch with our creative core. On the pages that follow, we look at how drawing can be a practice to reclaim and grow the creative self, useful to both the experienced artist and the novice. We will contact our imagination, open our minds and have fun. We'll see how drawing can bring us to the place of confidence and freedom. Learning to connect with our higher creative selves will not just change our art, it will also change our lives and even the world we live in.

Now, pick up your pencil and read on!

Lizzie

Introduction

"Every child is an artist. The problem is how to remain an artist once we grow up."
—Picasso

· · · · ·

Often when new acquaintances discover I'm an artist they say, "I can't draw at all! I can't even draw a straight line!" They laugh, but it's easy to catch a glimpse of a slight panic, too. "But you can," I say. They laugh harder, insisting, "Oh, no!" And then my heart breaks a little. Don't they remember when they were kids and drew with complete confidence? Of course, they're right: to be a visual artist takes skill, and that only comes from long, hard work. But behind the laughter is often the wish for that childlike freedom of expression that we all lose to some extent on the journey to adulthood.

Artists, too, can lose that sense of freedom. Sometimes I meet artists who are stuck in their work. They know they can draw, but it looks like there's some kind of dark cloud over their heads. They don't know the way forward in their art. Their work no longer feels vital. At times, they feel no one cares or values their work. All artists reach impasses, but these may grow into canyons of doubt. Sometimes an artist doesn't know how to jump into the flow of creative connection again, how to feel happy about their work or life. Something has happened; the artist has lost touch with the spontaneous connection to creativity we all knew as children, and with the belief that it matters. Perhaps they never were fully conscious of it. What's going on?

Kids draw with abandon. If we give crayons and paper to a small child, they will happily make marks. They don't care whether the marks look like anything—there's joy in seeing something where, a moment before, there was nothing. The child doesn't judge their scribbles but takes deep pleasure in them, and for a few moments is totally engaged in the act of creating. It's not about being "good" or looking "good." It's simply about do-ing and seeing.

When we grow a little older, we draw from imagination and memory. We develop a simple, symbolic way of drawing to tell stories, explore the world, and mas-ter the deep well of feeling, even fear, within. What would happen if our parents were

kidnapped? Where did our grandparents go when they died? Children often use drawing to explore and reflect. Rockets and fighter planes dart through mysterious explosions in the sky. Dragons prowl the land, and swords are drawn. Mothers hold babies, and birds fly overhead. The sun shines—a huge yellow orb in the sky. Parents and siblings stare out at us, often with huge smiles. The kid's home is there, usually with a tree or flower beside it, signs of life's grace and abundance, whether or not such trees or flowers exist in actuality. And the child is there in the center of the page, at the center of his or her universe. Children's drawings are full of imagination, assurance, and vitality.

Kids take a lot of pleasure in showing their drawings to others. They're only a little offended if you think that the person they drew is a bird. They're very pleased when the correction is made and we admit our mistake. It's not a big deal.

It's only when we get a little older, around the age of 12, when we're more curious about the bigger world around us, that we decide our drawings really ought to look more like what we see. We want to make grown-up work. Many of us become embarrassed when we only know how to draw people with stick arms, but there's often no one around to show us how to draw with greater competence. In school, if art is taught at all, we might have a class once a week for an hour or two. It's not enough time to develop skill or insight. The goal is always to make a "good" picture, something that can be graded, mostly by how "real" it looks, and perhaps hung on the wall. There's no chance now for real exploration, experimentation, or expression. Even worse, our art is given a grade!

For the most part, our public system of education seems not to know that drawing might be a way to observe carefully the world around us, and to appreciate it. Nor that it can be a tool for scientific observation or to design what can only be imagined. Mostly drawing is seen as something separate, only for art making. Art itself is seen as something of far lesser value than the calculus that most of us never use once we're out of school.

With no chance to learn skills, many of us stop believing that drawing or art serve any purpose in our lives. We forget the wondrous things that drawing did for us as young children, how it helped us understand ourselves and appreciate the world around us. We may never think about the way drawing gave us a sense of peace and happiness, or why. Nor how it made us laugh. Many of us come to believe that we're not that "good" at drawing or we don't have "talent." Why wouldn't we give it up?

Later in childhood, most of us are very skilled at verbal communication. Words

are everywhere. We rely on them—they're fundamental to the way we communicate with each other and explore our world. There's no real need to draw, we think. We're not going to be artists.

Even so, when we give up drawing we might well lose something vital and important. Drawing takes us out of our rational, linear, thinking minds into our feeling, intuitive, creative minds. Some of us may lose contact with our creative selves to the point where we come to rely almost entirely on rational, linear thinking. Much is lost when we can't access our own creativity and see beyond the limitations of linear thought, which can only grasp what's already evident. It becomes hard to envision what doesn't already exist, to invent anything. And our lives, as a result, can suffer, too.

Many of us want to be artists in one way or another. We want to capture the freedom we experienced as children and give form to the invisible. We want to make meaning and find mastery over ourselves. We want to find happiness in the full expression of who we are. We want to feel inspired and full of energy. Indeed, we want to be the confident, creative people we are meant to be.

In whichever way we choose, in whichever form, we can all be "artists." We are all inherently creative. We may take photographs, or plant a garden, or cook, or write poetry. We may paint or sculpt or draw. We may choose our clothes with care, even flair, or design our home in a way that gives pleasure. We may design innovative programs for the computer or start a brilliant business that creates an excellent product and provides a living for others. We may raise children to be kind human beings and productive adults. We may run for political office and do inspired work in the public domain. We may be doctors or therapists who empower our patients to heal. It can all be art. The more conscious we become, the more we can create and manifest in this world. It isn't necessary to draw to do these things, but drawing can be a practice—a simple one—that connects us with our true creative selves again.

I hadn't thought much about these things until I began to teach drawing at a new art center on the fringe of Boston on Saturday mornings. I'd been an artist all my life and made my entire living from art for more than 25 years. En route, I'd met my own impasses and discovered the way through them. At first, I relied on dogged determination and simply

did things over and over until I got where I wanted to go. This was sometimes a tortuous process and I came to know it well, as many do. Then, some years on, I began to study yoga and, at the same time, energy medicine. So many of the concepts of eastern philosophy took me by surprise. My greatest awakening was to awareness of a true spiritual self that lies beyond our thoughts and emotions. It's not that I hadn't been spiritual in the past but through deeper connection with meditation I came to understand more fully the nature of connection and the idea of detachment.

One day, in yoga class, my teacher spoke about one-pointed focus and I had a sudden recognition. So many of the principles of yoga—one-pointed focus, observing the mind, allowing ourselves to be where we are without forcing—these were things I knew through drawing. I saw that drawing too was yoga—that it could connect us with our true creative selves and with Spirit.

This knowledge fueled my desire to teach adults, though I'd never taught before. Not only that, I'd never been to art school, so, when I began, I had no traditional methods of teaching drawing in mind. A lucky thing, it turned out, or we might not have discovered the ways scribbling and drawing from our imagination would lead us to make quantum leaps in our creative endeavors.

My students all had successful careers in fields other than art. Some had degrees in art but wanted to make art more central to their lives again. Some had not drawn since childhood but wanted to try it. Some came to class with trepidation but also with brave hearts. We began with no predefined course of action and no real inkling of the amazing discoveries we'd make together.

What follows are the lessons we learned in what has become The Saturday Morning Drawing Club. You'll find drawing techniques to develop skills. You'll also find ways to overcome creative obstacles, find peace, and step into being confident creators. There are many kinds of drawing and art in the book—some from members of The Saturday Morning Drawing Club and many from creative artists who have made their lives in art. The hope is that the art will inspire the creativity in you.

Cat Bennett—You Are Not Alone (from series)

1 Something Is Calling

"Follow your bliss!"
—Joseph Campbell

.

Something is calling—we feel the urge to draw. It may also be the urge to be free the way we were when we were kids, or to see just what we can do. We may want to be more creative or even to be an artist. If we're already artists, we may want to leap over the obstacles that are in our way, whether internal or external, or discover new dimensions to our art. The urge can appear in many forms: a vague dissatisfaction, a deep longing, an itch, a visceral sense of excitement, even. It comes when we're ready to explore.

Some of us who abandoned drawing and making art in childhood may think we're not artists, and it may make us feel a bit sad. Some of us might think we'll come back to art again one day; perhaps, today is the day. We've been willing to deny our inner artist or to procrastinate. It doesn't always feel good, but it's easy to grow comfortable with discomfort. Life can be tough, and discomfort can become so familiar it feels normal. But now we hear a call to pick up where we left off, to see what's possible. Drawing seems like a good place to start.

Some of us are just embarking on adult life. We harbor a secret desire to be an artist in whatever form, a desire we hardly dare speak. Don't artists starve to death? That's what we've heard. Anyway, we're quite sure others are better at it than we are—they're more advanced, for sure. The evidence is all around; we can't fool ourselves about that. Still we hear the call to begin, to ignore all the forces that want to contain us. We could try our hand at drawing—it will tell us if we have anything to offer, we think. Or maybe we know we are meant to be artists. Still, we hardly know where to begin.

Some of us may already be artists but we feel stuck, like we're doing the same old thing over and over again. The thrill is gone. Our hearts are aching, and we can't see the way forward. We wonder, even, if we ought to give up making art, but the thought is too terrible. Art has given us such gifts, but it seems to be withholding them now. We hear a call to do more, to go to new places, but don't know how to get there. Maybe we should do some drawing, go back to where we started.

Or we might be artists doing all kinds of wondrous things but want to explore,

discover, and create in new ways. We're excited because there are many, many possibilities. We're so excited we hardly know how to catch our breath. We think drawing might offer us a way forward or calm us down a little. We know already the way it opens the mind, but how shall we go about it?

The call is often no louder than a whisper, like the urge for a cup of cocoa on a cold winter day. It can be so soft, we think we can turn away and be done with it. Perhaps this whisper doesn't mean anything, but we wonder why it's so insistent. Occasionally we turn to answer, then turn away again. At that moment it growls like a dog, and we get a bit scared. Sometimes we even shut our ears.

What to do? If we're being called to draw or make art or write or sing, we can just say yes, even if we don't know what it means or where it will take us. It will take us somewhere. Here we are, with this longing for something good, for something as wondrous and elemental as drawing. We can just say yes and begin. We don't need to think much about it. Our minds will present a hundred reasons why we should begin, and perhaps a thousand more why we shouldn't. None of them matter. The only thing that matters is that something is calling us, and we have the feeling that if we answered that call we might walk on clouds. To that kind of call, we say yes. We don't hesitate—that makes it harder. Resistance saps our energy and gives us one more thing to overcome.

As the great blues artist Muddy Waters wrote in one of his songs: "Telephone ringing, sounds like a long distance call." He was talking about absent love, and so are we. It's the love for what is deep within us. It's good to take those long-distance calls; amazing things happen when we act immediately on inspiration.

② We Start Where We Are

"Start by doing what's necessary; then do what's possible;
and suddenly you are doing the impossible."
—St. Francis of Assisi

• • • • •

It doesn't matter how much art experience we have, not at all. We might think we have no talent and that, too, doesn't matter. The thought doesn't matter, nor does so-called talent. We can all draw. It doesn't matter if we've drawn for years or not at all. It doesn't matter if we dream of doing something wondrous and don't know how; the wondrous will come to meet our desire if we honor it and keep working with an open mind. Nor does it matter if our heart is racing—this is a new kind of practice, a new way of drawing and being. New ventures often cause discomfort. It will pass, as a stomach complaint passes. This kind of discomfort is nothing compared to the unending misery we feel when we deny what calls to us. So what if we feel anxious? We can tolerate a little anxiety; it's not so bad. We don't need to run away; if we do, the yearning will just chase after us! It's like that. Besides, we won't feel anxious for long, not once we get going. It doesn't matter if we know fully what our purpose is; we'll find it. It doesn't matter if we don't really want to be artists; we'll be artists of life. It doesn't matter if the Museum of Modern Art isn't knocking on our door; we will carry on in the direction of our desire.

We can start just where we are—with a blank piece of paper, a pencil, and a mind open to all possibilities.

③ A Moment of Time

> *"My secret for drawing is not a secret. It is sitting down and drawing."*
> —Maira Kalman

• • • • •

We can draw occasionally for pleasure, but the results are always equal to our devotion. A daily commitment of time yields greater gifts than spotty stabs at drawing. Why should we decide to spend time on drawing when we don't know what the results will be? We've received a call, that's why, and we're going to honor that call. We'll take it on faith because that's all we have at the start. And even when faith is weak, when we're uncertain of everything, we'll choose it anyway. Faith is a choice, really. If we do nothing, then nothing happens. Our every action creates change and in ways we can't fully predict. Positive action creates positive change. It's a law of physics: for every action there is an equal and opposite reaction. We're embarking on a big adventure.

If art is our avocation we may set aside many hours a day; if not, we might draw for half an hour daily, or more. First thing in the morning, at lunchtime, or perhaps with tea in the afternoon. Inside, outside—it doesn't matter. But it does matter that we show up with some consistency.

Some of us will draw just when we feel like it. That's okay, but remember the equal and opposite reaction. The force with which we commit ourselves is the same force with which results come back.

If we choose a regular time, drawing will become a habit. We won't always show up; other events will interfere: a friend will drop in, our boss will ask for a report to be finished two days sooner than anticipated, we'll get the flu. There are many, many things that can interfere. We won't beat ourselves up; we'll just do our best. In time, we'll bring consciousness to our decision to honor what calls us. Our drawing will become part of our lives—something we look forward to doing.

4 Any Place Will Do

"We're fools whether we dance or not so we might as well dance."
—Japanese proverb

∘ ∘ ∘ ∘ ∘

Virginia Woolf claimed that every woman needed money and a room of her own in order to write. This is a fine thing, of course. We wish it for all creative people on the planet, women and men. But if we wait for these things, we'll never begin.

We can just begin where we are. Why hold ourselves back or give weight to whatever it is we lack? We can celebrate what we have: our life, our desire, hands and eyes, minds and heart, paper and pen! Whatever we give our attention to grows. Wherever we are, whatever we have, it's enough to start.

If we have a room, we can say thank you and set up a table or an easel in it on which to work. If we must work at the kitchen table, it's not a problem; we simply clear the crumbs of breakfast away. If we're going to work in a booth at the local diner, we order a cup of coffee. It costs almost nothing. Or perhaps we'll work on our lap on a bench in a park—we can choose a fine park, one with a beautiful tree to shade us.

All places are good. We will not hold ourselves back with thoughts of limitation. Wherever we are is fine.

Julia Talcott—from sketchbook

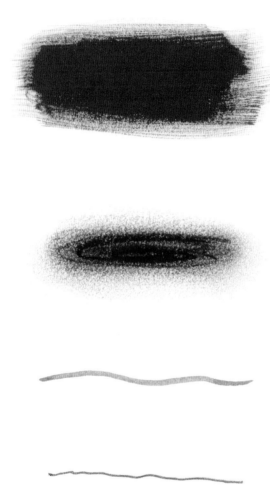

5 A Few Supplies

"Less is more."
—Mies van der Rohe

• • • • •

We only need a few supplies to begin; we can start with what we have. If we've been drawing for a while, we can choose whatever materials we'd like most to explore. Our drawings will be very different depending on the tools we use, of course, so we'll experiment as we go along and see what fits best with our own interests.

Often, when we begin a new venture, we hang ourselves up with thoughts about the setup. We think we must have a whole range of supplies, the perfect space, the right time. None of this is true. We can just begin.

Pencil, ballpoint pen, and felt-tipped pens all work well on cheap recycled copy paper. If we're drawing with crow-quill pen and ink or brush and ink, we'll need a thicker paper, such as Bristol. A smooth-surfaced Bristol will give us a smooth line but won't offer as much absorbency if we wish to add wash shadows or tone. A rough-surfaced Bristol will give our line more texture, and any washes we do will have more subtlety. We can use cheap recycled newsprint to draw with charcoal. Colored pastels will be more vibrant on bright-white drawing paper. We can also draw on colored paper, textured pastel paper, cardboard, wood, or whatever surface we feel like exploring. There's no need to spend hours shopping and accumulating all manner of supplies. So often it's best to start with a little and make the most of it.

If we're working on large paper, we can work on a table or an easel. If we're working on a table, we might want to prop a drawing board on a small stack of books, so we can see our work more easily without hunching over. Working at an easel allows us to stand up and throw our bodies into our drawing. But anything goes—we can do whatever we like best.

It doesn't matter if we draw small or big, but it's good to experience both. We'll find our own way. If we discover we love to do cartoon drawings or illustrations, we might well decide to work on a small scale. If we want to do drawings for exhibition, we might need to work large.

That's all we need to start, that and a willingness to step into the unknown.

Cat Bennett

6 The Ways We Draw

"All things come from nowhere. How vast, how invisible, no way to explain!"
—Chuang Tsu

• • • • •

There are many kinds of drawing: realistic (as much as anything can be), subjective, schematic, abstract, cartoony, impressionistic, expressive, controlled, free, tortured, obsessive, spare, inventive. We could go on. And on. But we'll divide drawing into three main categories: making marks, drawing what we see, and drawing from imagination. Children begin with making marks, basic scribbling, then go directly to drawing from imagination. As we grow older, we want the skills that come from doing observational drawing so that we can draw whatever we want.

Here, we'll begin with making marks and go directly to drawing what we see. Then we'll come back to where many of us left off as children—to drawing from imagination—but this time we'll do it with heightened awareness, a sense of our own purpose, and greater skill. Our goal is to find our creative voice, not to stop with careful rendering. There are now cameras to record the world around us, but we can still benefit from drawing it, if we're so inclined. Careful observation gives us a more intimate connection with our world, and knowing how to draw what's around us, in one way or another, can give us greater freedom of expression. Even if we focus on this kind of drawing, we want to discover our unique, imaginative self in it.

We'll soon see that drawing begins to ask questions—questions like, who are you and what do you want to say or do? We don't need to answer right away, just know that the questions will arrive, one after the other, at awkward moments, niggling like uninvited guests. We can be well mannered, of course, and hospitable, too. We provide a bed and a little food, but we'll go on with our lives and get to know our guests in time. We can't rush these things. Still, it's good to know that in drawing we don't just learn skills; we come to know ourselves as creative beings.

So, now, let's begin. Get out your paper, your pencils, charcoal, pens. Get out your ink and brush. From a tree outside , pluck a twig to dip into ink and draw with. As you read what follows, try each kind of drawing yourself. By experimenting, you'll start to get that feeling of freedom we need so much in making art and in living a full, rich life.

⑦ Making Marks

"Drawing is the changing point from the invisible powers to the visible thing..."
—Joseph Beuys

• • • • •

It may seem silly simply to make marks on paper, but no matter who we are or what our experience, it's a great practice and a good place to return over and over again. This is especially true when we feel stuck, uptight, lost, confused, uncertain, or any one of those dismal states into which we occasionally slip. Making marks frees our hand from the judgments of our mind and catapults us into the space of playfulness and presence. How can the mind complain when we're just fooling around? We want to get to this place of free expression in all our drawing, and making marks is a good way to practice. It trains the mind to let go. It trains us to just be and to see.

When we were toddlers, we scribbled with crayons on paper or even on the walls. Once we had a crayon in hand we had to make marks! Kids seem to understand instinctively how exciting it is simply to see what emerges when we show up to draw without any plan. They're undaunted, free from judgment, and filled with positive expectation.

I knew nothing of the benefits of making marks when I began teaching adults. Apart from idle doodling, I hadn't ever sat down to intentionally make marks on a large scale. My teaching plan was to start right in with observational drawing. But on that very first morning, a student who had not drawn since the age of six suddenly blurted out that she was terrified. She didn't know how to draw, she said. I'd never imagined the feelings people have around drawing are so strong. Yet we've encountered them again and again.

"Okay," I said, "we'll just start with making marks. Any kind of marks. We'll just scribble for a while like babies do." I thought I'd make it very comfortable.

The class all nodded, and I put on some loud rock music—U2, in fact—soaring music that takes you right out of yourself. I was almost congratulating myself on the way I was easing them into drawing, and started right in with our first exercise. I'd decided to draw alongside them, so they could see that drawing is an exploration for everyone, no matter how much experience we have. There's no right way to do it. I really wanted to avoid that feeling of a teacher watching and judging. It's a sense of judgment that got many of us hung up in the first place.

Making marks was totally new to me, but I saw the fun of it right away. It's liberating to just splash around without having to make something look good! For someone who'd been an illustrator for a long time, this was real freedom. As always happens when I draw, in whatever way, I was soon lost to the creative side of the brain, where not much else intrudes. I saw at once how full of possibilities making marks is, how one line leads to another and that the lines themselves begin to convey energy and suggest worlds of meanings. But when, after a few minutes, I looked up, I saw that most of my students were still staring at their papers, and frowning.

"What are we supposed to do?" said one.

"Just scribble," I said.

"Just do anything?"

The idea of freedom proved almost more daunting than trying to draw from life. So I decided to call out a few instructions.

"Make a long snaky line," and, "Add some dots!" After that, they didn't really need more encouragement. They, too, were soon engrossed in what they were doing, immersed in the creative right brain.

As already stated, the left brain is the verbal, analytical, linear side of our minds. Creativity, intuition, spatial thinking, and feelings reside on the right side. In drawing, once we've done it for a while, we slip into the right side of the brain effortlessly. We'll notice that we don't feel anxious at all. Not only that, we seem totally absorbed in our own world and may not even hear other people speak to us. If we're chatting with our neighbor as we draw, we're still in left-brain mode. On the right side of the brain, we soon lose track of time. There's nothing but the present moment and what we're doing.

Scribbling is hypnotic and freeing. This is the place we want to get to in all of our drawing and creative work. The more we practice, the more we learn to slip into it with ease. It's important to notice this state of being so we can easily find it again. We are not judging our work at all. We aren't thinking a lot. Thought does dart in, but it leaves just as quickly when we return our focus to what we're doing. This is what yoga calls one-pointed focus; in drawing, all of our attention is on our hand and what is emerging on the page. We're totally present in the moment.

On that first day we drew like this for 15 or 20 minutes, then stopped. Creative energy is powerful, and we need to build strength through practice in order to sustain ourselves in this place without getting tired. So, to start, a short amount of time is enough. Afterwards, we laid our drawings out on the floor in the order in which we'd made them.

In most cases, the first two or three drawings were awkward, even timid, and revealed the discomfort each artist felt in doing this seemingly strange exercise, something none of us had done since early childhood. Already that was interesting. In drawing, we can't really hide. If we hide, it's quite clear that we are doing so. Our presence or absence shows up on the page.

We also noticed right away that each artist has a unique hand. When I called out things like "Draw a wavy line," each wavy line was different. This was a huge and beautiful realization. If we can stay true to ourselves as artists, we have something powerfully unique to manifest. In order to be true to ourselves, it can help to come to know ourselves in this raw, innocent state.

As the number of drawings grew, each artist explored territory particular to what they'd seen and discovered in their first drawings. Each new drawing came from discoveries in the moment. The practiced artists sometimes reverted to practiced ways of making marks, even slipping into making representational drawings. The new artists sometimes found one way of doing things and stopped there. But everyone did something unique— sometimes in a tentative manner, sometimes in a bold way.

Even more interesting, in making marks we can begin to discover metaphor and make meaning. It happens in the midst of the process, often after doing several warm-up drawings. Suddenly in the midst of a drawing, it no longer seems random. We begin to perceive relationships among marks, to see what they might express—by the qualities in them, by the way they relate to each other, and by how they are situated in space. This magical moment occurs right in the midst of drawing and is creative intelligence at work, making order out of chaos. It happens, too, in other kinds of drawing and in all creative work, but it was great to see how it happens when we're just making marks. Because the marks are abstract, they can be full of feeling and discernment, and certainly mystery. Both the artist and the viewer create meaning as they look at the marks and allow their own feelings to surface.

The greatest thing we discovered that very first day—and it has held as a truth ever since—is that the simple practice of making marks catapults us instantaneously into total presence, oneness with the moment. It's the place of peace and happiness. The joy in the room when we finished drawing was palpable. It was as if we were all kids again. It was the moment I felt truly inspired to write this book. Drawing is yoga.

There are lots of ways to practice making marks. Here are a few you can begin to play with now. There are more exercises at the back of the book.

Draw to Music

Try drawing to different kinds of music. Find music that opens up your feelings or that creates a sense of calm. Try music with a strong beat that gets the blood flowing. Music can help us by taking us out of our thinking minds and bringing us fully into the present moment. We can let our hand follow the music and see how different music and emotional states change our drawings. We're looking for the expressive qualities in our drawing when we let go of control and splash around.

Draw by Touch

We can touch different textures and draw what we feel: a smooth stone, a wooly sweater, the skin of a pineapple, sand, a cotton ball. Textures will ask us to make different kinds of marks. It's a way of building our expressive tools.

Draw with Different Materials

Try drawing with pencils, markers, charcoal, pen and India ink, brush and black paint, a twig. We can also try colored pencils and markers, pastels and colored paint such as gouache, an opaque watercolor. This is a good way to become familiar with the way different drawing instruments make different kinds of marks. We can smudge charcoal and make marks with the charcoal dust on our fingertips. We can apply ink or paint in a wash, or use it full strength to make deep black. We can press hard on our pencil or apply almost no pressure at all. By doing these things we can discover all sorts of ways of drawing. For those of us who are already familiar with different drawing instruments, experimenting can be a way to get out of habitual patterns and see new possibilities for our drawing. We can also draw on different surfaces, both smooth and rough papers. Draw with black on white, then with white on black, or on colored papers. Try everything. Really take the time to play! Forget about "looking good" or "being good." Just make a mess and see what happens.

Draw with Eyes Closed

It's amazing to close our eyes and draw! We'll make marks we wouldn't otherwise and find a whole new vocabulary to use in our work. We can't care how things look when our eyes are closed. That's good because it's our concern that often inhibits us. It's fun to see what comes out. Our line will look different when we draw with our eyes closed. Drawing with our eyes closed is a great way to become unstuck.

Draw Slow/Draw Fast

Varying the speed with which we draw is another way to experiment. We can draw slowly and see what the nature of our line is, or if we perceive more as we go along, or if we get ideas for what we're doing. Are we being too careful? Do we have a tendency to constrain ourselves or worry when we draw at a slow speed? When we draw really fast, we'll see our drawing is very different. Our lines may well be full of life, vibrant and happy, or nervous and agitated. In the random splash of lines and squiggles, we might see something that can be clarified and ordered in the next drawing. Making marks is a dance among random events, insight, intention, control, and inspiration.

Cat Bennett

Images rescued from back of ancient Chinese screen at The Isabella Stewart Gardiner Museum in Boston during restoration. Courtesy of Aparna Agrawal.

Doodle

We can just doodle, something many of us do whether or not we're artists. When we doodle, all sorts of shapes and lines emerge. There's no need to think, just allow. We can just show up and see what comes to meet us. After we doodle a bit, we can doodle things along. Images may begin to emerge, and we can just play with them unselfconsciously. We can play with drawing. We can be silly or wild or try on a dozen different hats. When we're doodling it doesn't seem that serious or daunting.

As we go on, we might use a lot of what we discover, or just a little. We're each of us different as artists, and our concerns are different. Some artists are more sensing and will return to sensual preoccupations like line, color and texture. Some artists might veer towards stylization and cartoons, depending on what they feel they need to say. Others are more conceptual, concerned with trying to get a grip on ideas and give them visual form; they may need minimal gestures or very involved ones. Some want to explore feelings and may use every mark they've discovered. But all of us will use the freedom and literacy we learn by making marks.

We'll also begin to see what matters to us. What is it that excites us? The tone of grey and how it might be used to describe the world around us? Or the way a small line, sitting in a vast space, commands our full attention? This practice asks us to suspend what we think we know and to simply explore. Not everyone is comfortable doing this, and we can note where we are. The truth is that, in every living piece of art, we can't fully anticipate what will emerge until it has taken form. Making marks gives us a chance to get comfortable with uncertainty and to see that some kind of transcendent order can always emerge out of chaos.

Making marks gives us a chance us to play with drawing. In The Saturday Morning Drawing Club, there was a lot of laughter in the room, kid laughter. It showed us that when we're drawing, we're don't need to get anywhere. We can just show up and have fun. We can be fully present in this moment of time. We get to see that drawing is not just about making something for the outside world; it's a way of exploring, thinking, discovering, expressing, playing, and coming to know ourselves. The question is: Do we remember how to play? Really play? Can we go wild? Can we forget about results and just see what happens? Will we take the time to play? This is our chance to let go and try everything. Now is our time to play and experiment. Without play, we don't go far.

Appendix 1: Drawing exercises for **Making Marks**.

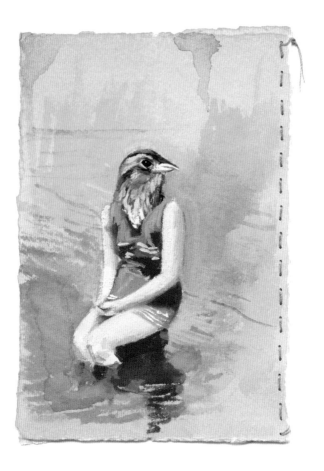

Kaetlyn Wilcox

8 Drawing What We See

"Seeing is forgetting the names of the things one sees."
—Paul Valéry

∘ ∘ ∘ ∘ ∘

While children move from making marks to drawing in a schematic, imaginative way, we'll go directly into observational drawing and come back to drawing from imagination and memory later. Observational drawing is not about being perfect or getting it right; it's about looking and giving form to our perceptions. Our fledgling efforts might be clumsy, even inept—this kind of drawing is a skill learned through practice and comes more easily to some than others. If it feels difficult, it's not a problem; practice will help. Our drawing skills will soon catch up with what we want to capture on paper.

In drawing from life, we learn to see with greater care and to develop appreciation for what we see. Observational drawing may come more naturally to those who are very sensing in their perceiving, to detail-oriented people. Some of us, myself included, are more intuitive and pay less attention to the fine details of the physical world. We can strengthen our sensing through observational drawing. We can bring our awareness and personality to the drawing so it communicates something of our interest to the viewer. Close observation gives us the space and time for our perceptions about our subject to emerge with clarity and be felt. We come to know what we feel and think. We come to know ourselves.

The great Japanese film director Akira Kurosawa once said, "An artist is someone who never averts his eyes." In 1923, the Great Kanto earthquake killed 100,000 people and destroyed Tokyo. Kurosawa was just 13 years old and walked amongst the devastation of human and animal corpses. When he tried to turn away, his older brother instructed him not to avert his eyes. As a result, Kurosawa came to believe that looking at the whole of life was a way to defeat fear. As artists we're building our courage, and drawing can be a great teacher. It teaches us to look no matter what's going on, and it uncovers all the shadowy, hidden places in our heart that want to come up into the light.

We'll have to ask ourselves what we want to draw. Are we attracted by nature? Do we want to draw people and come to know them as we draw them? Do we learn something by drawing a still life? Do we want to say something about the suffering in the

world? Do we want to say something about the light? Drawing from life will lead us to our own preoccupations and insights.

What follows are ways to practice. It's worth spending time on each technique, then returning to them at our leisure. It's not as if we learn to draw and that's it. Drawing is a dynamic, ongoing enterprise. There's no stopping place, just new explorations. One thing to note: we're not trying to make a "good" drawing here. If we can't go overboard in one direction or another, we won't find our way. Feel free to bash about, try different drawing implements, draw in different ways, and choose all sorts of subject matter. We only learn by doing. Don't be afraid to draw the same thing 10 times, or a hundred!

It's good to note that in observational drawing we look more at what's in front of us than at our paper and hand. Our eyes are mostly on our subject—seeing, feeling, and allowing our hand to follow on the page with occasional glances, and stepping back once in a while to study what we've done. We'll slip into the right-brain state of mind in exactly the same way we did with making marks.

Often beginners are afraid they're "no good" when their first efforts disappoint them. Our first efforts will disappoint us if what we're looking for is accuracy. We haven't practiced enough yet. We have a long way to go. But we have the benefit of everything being new and fresh. This helps us to be fully present to discovery and learning. More experienced artists have practiced so often, they sometimes fall into such habitual ways of drawing that they're no longer fully present in their work. For them, it may help to try drawing in different ways. Our main goal is to be fully present in the work, just like in life, and to know that learning to draw with accuracy and expressive quality is a process.

What follows are brief descriptions of various ways to practice, with examples from both experienced and new artists. As we'll see, all the drawings have both power and charm, no matter the artist's experience. As important as the subject in a drawing is the hand and spirit that made it. You can begin now to practice these techniques as you read about them here. Choose some simple objects and set them in front of you to draw—a sweet potato, a sprig of honeysuckle, a glove. Whatever seems fun.

When a group of people make observational drawings of the same object or person, the drawings will all be different and in radical ways. If we experiment with materials our own drawings of the same subject will be different. Remember: we can play here, too.

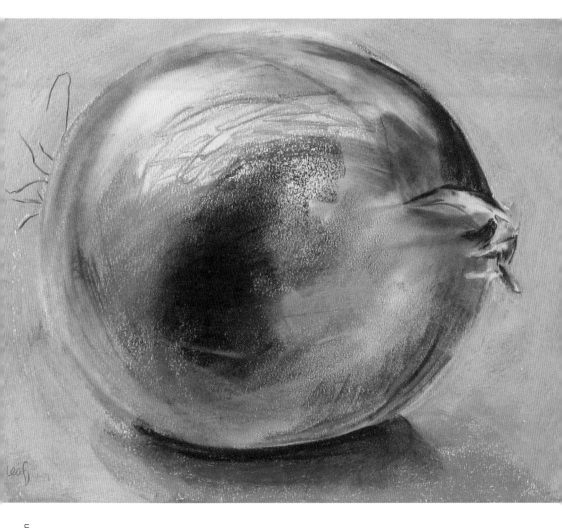

Caroline Leaf—Green Onion

Kaetlyn Wilcox—Edie in the Hot Tub

Gesture Drawing

In gesture drawing we try to capture shapes in a spontaneous way by moving our hand quickly and keeping it in continuous motion. We can try making a sketch in a few seconds, again with our eye more on what we're drawing than on the paper. After we've done a few such drawings we'll have memorized the shapes and can try to be more selective in the lines we draw as we look at our subject again. The main thing is to keep the hand moving. These drawings will be full of life, spontaneity and surprises—so this is a good way to practice to avoid stiffening up with effort. We can capture the essence of what we're drawing without obsessing about details.

Deborah Putnoi (left)—drawn on cell phone; Cat Bennett (right)

Drawing with Shapes

Seeing in terms of defined shapes can be another way to practice. We had great success with it in The Saturday Morning Drawing Club. It was particularly successful when we drew faces, which can be daunting for the beginner. We can look at whatever we're drawing and begin to break it down into shapes. Sometimes, it's enough to simply do this mentally or, if it's easier, we can pencil the shapes in lightly on paper before going back in to draw in more detail. Drawing the shapes first allows us to forget about whether our drawing looks like what's in front of us, a hang-up that often gets in the way. It also allows us to get the big picture before going into detail. Drawing this way helps us place things in space with some accuracy, especially when we're beginners.

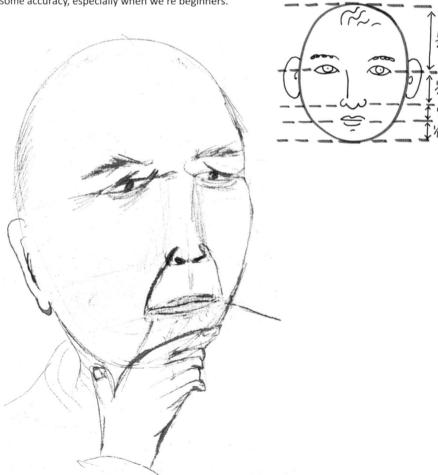

Margaret Metzger

Drawing the Space Between

Here, we look for the spaces between shapes and draw those rather than the object itself. At the beginning, we can do this in a messy way without concern for the end drawing. After we have a mess of lines on the paper, we can begin to pick out the lines that really reflect what we're seeing and go over them. Later we can draw the shapes lightly on the paper or even in our heads. It's a way of learning to see with greater accuracy. Observing how lines relate to each other and how one leads into another can be a helpful way to learn to draw accurately without getting too judgmental about whether our drawing looks like the object in front of us.

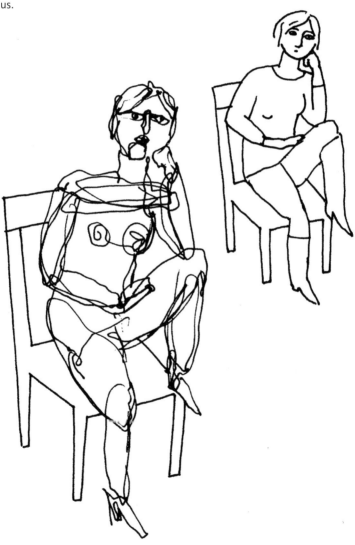

Drawing with Tone

In the chart we can see a range of tones from light to dark. Now, when we look at an object, we can try to draw the tones, starting with the darkest and leaving white space for the lightest, or doing the reverse. Either way is fine; it only matters that we work with consistency. We'll need a soft ebony pencil, charcoal, or even ink wash or watercolor for this. Often, beginning artists work in the middle range and need to look closely to see there's more drama, and contrast, than we sometimes think. Having a full range of tone, from white to black, brings depth and energy to our drawing and gives us a greater sense of an object in space. We can add line also to pick out details and the edges of objects. It's possible to start with line and add tone as well. Try experimenting.

Contour Drawing

Again, we allow our eyes to focus more on what we're drawing than on the page and try to capture the essential form with line only. We move our eyes slowly around the contours of an object, checking always for relationships between one line and another. Our hand simply follows our eyes, and we let our eyes flit from looking carefully at the object in front of us to a quick glance at the paper to see where our hand is and how one line relates spatially to another. We can watch for the negative spaces between the things we're drawing. We can begin to notice our own drawing preferences. Are our lines sketchy? Do we prefer bold sweeping lines? Either way is fine, but each expresses something different.

Blind Contour Drawing

Here we don't look at the paper at all; we look only at what we're drawing. The surprise is that often these are our most accurate drawings. When we look at our paper our mind often leads us astray, telling us that we're not "getting it" or making assumptions about what's there. In blind contour drawing, we look only at what we're drawing and let our eyes move in concert with our hand. It's a lot of fun to see the results. Often, the quality of the line is full of life and interest. This kind of drawing can give us a lot of ideas about the expressive possibilities and be very freeing.

Maude Bigelow (left); Maggie Stern (center); Carole Katz (right)

Blind Blind Contour Drawing

One day, in The Saturday Morning Drawing Club, we experimented with drawing with our eyes closed. For three hours, we drew from memory—flowers and faces, people we knew well. The results were astounding. The drawings were full of life and often quite accurate, even though we never opened our eyes! The next thing we did was study an object or a photograph for a minute or so, looking with care and following the contours with our eyes, then we closed our eyes and drew. Sometimes the results were spatially distorted, but with repetition they became more accurate. This is a great way to draw because there is no judgment getting in our way. It's really useful for the experienced artist who wants to con- nect with the authentic quality of their hand and bring freshness back into their work. It's also fantastic for the novice for whom drawing seems difficult.

Drawing with Our Nondominant Hand

After we've been drawing for a while, we might become a little jaded or lazy. We want to try something new and bring new energy into our work. We can try drawing with our non-dominant hand. It engages our brain in a different way, and we can't draw with the same efficiency or control. It also frees us from the judging mind. Our drawing will be wilder and more spontaneous. It might even show us new ways to explore.

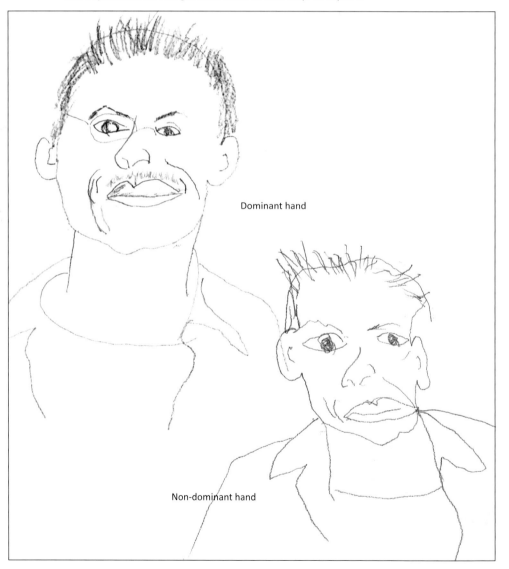

Dominant hand

Non-dominant hand

Maureen Cook

Drawing Upside Down

When we draw upside down, we're forced to let go of all the assumptions we have about how things look and pay close attention to what's really there. Choose a photograph or line drawing, and place it upside down. The important thing is to draw it upside down, too. We won't see the results until we turn our drawing right side up. Often, these drawings are surprisingly accurate. Often, we see much more this way, and it's good training in using care when we look.

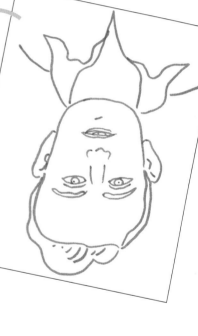

We can become aware of those times when we aren't looking carefully, when our mind has wandered and our hand, too. We may see some interesting exaggerations in our drawing, fuel for future explorations.

We can also make up our own ways of exploring drawing. In time, if realism is what interests us, we'll find our own style of drawing and what it is we want to express. Some of us will be interested in observational drawing, and some of us won't. By drawing in different ways, we'll begin to discover what interests us and why. The boundaries between categories soon blur at any rate. Nothing is completely observed and nothing completely imagined. Even making marks is not strictly from imagination—energy also plays a part as it does in all forms of drawing.

It's good to try drawing many kinds of things. We might want to start with simple shapes—a sweet potato, a pear, a stone. Even these will offer us more to draw than we might first think. There's texture and shape, dark and light, the shadows the object casts. We can think about how we place the object on the page, whether it's in the center or off to the side, and what the placement suggests.

We can then challenge ourselves with more complex objects—an eggbeater, a bicycle, a vase of flowers. We can ask a friend to pose for us or draw from photographs. We can draw the figure and also faces. In many ways, the human face is the most challenging: we discover more about the character of the person as we draw, and we discover more about how we feel too. We can sit in a café and try making quick sketches of the people around us. Or we can forget the figure and sit outside in nature and try to distill the details of trees, hills, and clouds into simple forms that suggest the richness of the landscape. With all of these things we'll choose what feels important to us. Drawing is a way to share our appreciation of the world around us.

We'll learn to see more clearly when we draw from life, then to distill what we see and feel into a coherent drawing or art. It takes practice. At first we may be disappointed in the results. It happens to us all and our response simply can be to begin again. Over time we'll find our own way of drawing. Everything will show up—the choice of what interests us, the careful selection and omission of detail, and our feelings about what we see. We'll include the marks we know how to make as we explore and examine our world.

Kathy Todd—Minnows

Appendix 2: Drawing exercises for **Drawing What We See**.

9 Drawing from Imagination

*"We but half express ourselves and are ashamed of that
divine idea that each of us represents."*
—Emerson

∘ ∘ ∘ ∘ ∘

Kids move directly from making marks into drawing from imagination without bothering to learn how to draw from close observation of the real world. They make symbols for the things they want to express: a blue stripe across the top of the page for the sky, a large circle for a head with only a stick body. Anything will do.

Pictures of family, the dog, birds, and trees express the pleasure children find in the world they live in and their place in it. But they also use drawing to explore and master their relationship with the mysteries of life. Where are we in face of monsters? What's our place in the world? And what about death? Children go directly to the deepest part of themselves, even to fear and uncertainty. They picture ways to overcome fears and connect with a sense of power. Sometimes, they picture themselves as heroes, but they're willing to see themselves as vulnerable, too, when they feel that way. Kids go to the heart of what matters to them. They tell their truth.

Now, here we are, all grown up. What will we do? In drawing from memory and imagination, we draw again like children. We get to do all the things that we did as kids with adult awareness. We can celebrate the pleasures in our lives, explore the mysteries, and create whole new worlds. But will we dare to go as far as we did as kids? That's our challenge.

Here's where we meet Walt Disney and Winsor McCay, Istvan Banyai, and Maira Kalman—all great inventors of fantastic worlds of their own. Disney's Mickey Mouse is sheer invention, the center of an imagined world that is childlike in its sweetness and kinder than the one we live in. In the early films, before the Disney studios became so commercialized, Mickey had immediacy and charm. It's a dream world—one we imagine might somehow be possible if only we could be mice! But we, too, can live in this world while we visit with Mickey on film or in a comic book. He will take us into our own sweetness.

The cartoons of Winsor McCay were drawn in the early 20th century. In them, Little Nemo eats too large a dinner, then falls asleep and experiences a whole world of

adventures in which he has enormous powers or is utterly helpless in the face of morphing reality. These cartoons explore the nature of dreams and psyche while looking like a comment on mere indigestion!

Istvan Banyai's world is not so benign. Here, we take a walk on the wild side with too-short skirts, spiked hair dyed in rainbow colors, and smoke everywhere. What's invented here is the style; Banyai's world is cartoonlike, even as it depicts the lives of young people on the edge of what looks like heartbreak and sometimes danger. But the sheer verve with which he draws, the sinuous way in which his characters move, the vivid colors—this is also what it means to be alive! We know these folks will dissolve into pools of tears from time to time, as we have ourselves when we went too far or not far enough. But Banyai's characters are exploring life, like pilgrims. This is what it is to be alive! We fear for them and feel for them. We wonder about this world we've created. Much of Banyai's work is sheer invention that feels very real.

In drawing from imagination, we invent a world that resonates with our perceptions and beliefs. It's informed by our unique experience of life: our preoccupations, persuasions, and skills; our awareness and our heart. Like children, we need to travel to that deep place: our own truth. We'll likely have to go through the darkness to get to the light. The style in which we draw speaks volumes. To create a coherent world we'll have to make decisions, we'll have to know what has meaning for us and be creators of a vision we really want to share. Our style will emerge from the nature of our hand and from our life and intention. Style is character; whoever we are will show up in our art.

When we draw from imagination, we reference the world around us but create a whole new world. In Maira Kalman's book, *The Principles of Uncertainty*, she records her travels and her feelings in drawings. She notices what we might not and brings compassion to the page in telling moments of bravery or vulnerability. Her work is grounded in observation, but her own spirit is vividly evident in the "naive" quality of her drawings and their intense color. Is it strictly drawing from the imagination? The boundaries blur. This is personal work; the colors and lines are heightened in imaginative ways to convey her perspective.

These distinctions—making marks, drawing what we see, and drawing from imagination—blend at a certain point. Everything comes into play. In our mark-making something of the real world might appear, and our own hand will be fully on show. In drawing what we see, we'll also include our feelings and perceptions. We may all be drawing the same object and doing it in different ways, but the emphasis is more on the object than

on the perceptions of the person drawing. In drawing from imagination, we use the marks we've explored and the memory we've developed from observational drawing to assert our own vision, with or without the use of references. The emphasis is on personal expression.

Children draw wholly imaginative worlds in which they master and express their feelings. As adults we, too, can create imaginary worlds, master and express our feelings, and share our vision. The work doesn't need to be emotional, or even representational. Some of us will focus on the expressive qualities of pure form. As we create our visions, some of us will draw totally from imagination and memory. Others will use references from the material world. And still others will draw in an entirely abstract way. Whichever method we choose, we're making art that takes us to new places as artists and tells new stories.

To practice drawing from imagination, we can just get out some paper and start drawing. Perhaps we'll need prompts of some sort, such as words or objects or stories. Perhaps we'll need to look at the work of other artists to see what's possible and get ideas to begin. As Picasso said, "Good artists borrow. Great artists steal." Take whatever you want but make it yours.

There's no need to rush. Our work will develop over time. Our style will become clear and we'll find different ways to express our visions. Feel free to play and explore. We need to be intrepid travelers when we leave the comfort of the familiar. What follows are a few ways to begin your own trip.

Katherine Dunn—The Swimmer 2

Draw from the Mind

Practice drawing from memory and imagination. Draw people, animals, landscapes. We may need to use references from time to time, but we'll begin to create our own symbolic way of drawing, our own style. The way we render our world communicates volumes. The way we draw depends on our own nature and what we most want to say or explore. Often, we can't put this into words, and it's not something entirely under our control. We are who we are. We don't need to think too much here, just explore. We can make dozens of drawings and begin to see our own nature. Are we gentle and understated, funky and fun, fierce and brooding, or any combination of these or a thousand other things? By drawing, we can begin to find our most natural expression. In time, our style will evolve in keeping with our own growth, just as Picasso's did.

blackberry

Susy Pilgrim Waters (left); Michael Crockett (right)

Cat Bennett (bottom)

Discover Your Style

Observe the nature of your hand and take note of what you love. Find what you want to explore in your drawing. Perhaps it's your slinky, declarative line. Perhaps it's the sensitive way your shading creates a sense of realism. Maybe you feel most at home with cool simplicity. Maybe you're turned on by wild, expressive dark lines. When you begin to see what you love most, you can focus on it and make it yours.

Experiment

Most of us need to explore and experiment. If we always do things one way, it's good to try another way. If we always draw from life, we can try drawing from imagination. If we always draw from our heads, we can try making observational drawings for a while. There's always discomfort when we do the unfamiliar, but it doesn't matter. Do it anyway. Draw with one color or two. Draw with a twig and paint or splash water on paper and draw over it. See what the expressive possibilities are. Paste a square of pink paper on brown cardboard, then draw over the paper and the cardboard. Add a smudge of pastel green. Draw on a cement wall, just for fun. Get a roll of paper six feet wide and tape it to the largest wall you can find, then fill it with blind contour drawings. Think of a hundred ways to experiment, then add a few more. Try them; it will change everything.

Deborah Putnoi (left); Connie Henry (right)

Use Word Prompts

Write out a list of words that might stir the imagination—words that have meaning to you. Now make drawings that come from these words. Here are a few to try: love, stone, bird, lake, hunger, fly, branch, shoe, noise. Now write combinations of vivid, evocative words that can be pictured any number of ways: pink skyscraper dream, waterfall dress wing, hangover cloud house, bug hill mind, red moose man. Write your own, then create images.

Change the Materials

If you usually draw in pastel, try using a twig and India ink. If you usually draw in pencil with soft, subtle lines, try drawing with a black marker. If you most often draw on white paper with black ink, try black paper with a fine metallic pink marker line. Play with materials to see what you really love and what suits your intentions as you go on.

Study the Work of Other Artists

When we study others' work, we see what resonates most for us as artists. We can visit museums and galleries, pore over books, scour the Internet. Most cities have open-studio weekends, where we can visit artists at work. What is it about the art that excites you? What is it about other artists' work that resonates with you?

We can think about who we are and where we want to go with our art. Maybe we don't want to go anywhere. Maybe, for us, drawing is a meditation, something fun and enjoyable. That's a beautiful space to be in. Or maybe it's the beginning of art making, or an art in itself. We can see what drawing means for us, and what our intention is.

Susy Pilgrim Waters

We need to think now about what is important to us, about who we are. What do we want to say? What do we want to offer the world? We experiment with visual means to express what we most want to communicate. We try things out and see what quickens our pulse, what fully engages us. Our explorations and self-awareness grow over time—through drawing, through our life journey, and through seeing what matters to us, what moves us. Are we willing to get out of habitual patterns to explore what might be possible? Are we willing to make mistakes, to go too far? Can we take chances? What will we explore?

Different genres of art go into the world in different ways. There are lots of ways of being an artist—some humble, some public, all fine. Art and the way it enters the world will continue to evolve. We can begin to examine the most appropriate expressions of what we feel we're here to do and how we might be artists in the 21st century. This kind of study is not done in a day; it's a lifelong exploration. And we must be prepared for our goals to change along the way.

We're here to be ourselves. It's easy once we know we don't need to impress anyone. We can just be where we are. Art, like life, develops organically. We can't rush it or force it; we just need to show up and do the work, pay attention to what's there, and respond to inspiration. We're all in different places—that's what's so interesting. Staying true to ourselves is the main goal.

Our ideas and feelings are the heart of our work. Where do ideas come from? How can we receive them? What do we want to create? We'll explore these questions in greater detail later. First, though, let's look at the concept of energy.

Appendix 3: Drawing exercises for **Drawing from Imagination**.

Cat Bennett—Always Blooming (left); Looking In—right)

 Energy

"We alchemists look for talent that can heat up and change."
—Rumi

• • • • •

Physics tells us that everything is energy: the universe and everything in it, including ourselves. Matter is made up of atoms, electrically charged protons and electrons. When temperatures reach absolute zero all energy vanishes, but scientists have shown that quanta, the tiniest particles within atoms remain connected and still influence each other, even at a distance. It appears there is a level of information or intelligence that influences energy. As John Assaraf writes in *The Answer*, "the undifferentiated ocean out of which energy arises appears to be a sea of pure consciousness."

Let's follow the logic:

The material world, including our bodies, is made of atoms.

Atoms are formed by energy.

Underlying energy is Infinite Intelligence

What does this have to do with drawing or making art? When we make art, and even when we're drawing, we tap into the energy and intelligence of the universe—if we can get out of our own way.

Art begins with a clear idea or intelligence. If we don't have that, the results are muddy. Most of us root around in the muck a bit to develop our skills, play with possibilities, and discover who we are as artists and people. Experimentation is a very necessary step. But as we go on, we get clear about what we're doing.

Is there some way we can tap more easily into the energy of the universe? Yes. The quality of our own energy affects our ability to receive inspiration and take action. When we're in the high vibration of positive expectation we are in the part of the brain that opens a clear channel to inspiration. If we take immediate action, we jump into the creative flow. Negative, worrying energy resides in the left-brain thinking place and makes us feel heavy and tight, as though our feet are planted in cement.

So, let's think about how to be in that bright space. Sometimes, in the face of hardship or loss, we'll be sad, of course. There are many circumstances beyond our control, and suffering comes to us all. At such times, we must allow the space for sorrow to pass

through. Sometimes, though, we create sadness and hardship by habits of thought. We've all done this. Think of the folk tale of the Chinese man who was angry his son broke his leg because it meant the son could not help harvest the fields. Then war broke out, and the man was happy because his son could not be conscripted to fight. Things happen, and it takes time to begin to understand the larger story or the gifts of a situation. Our emotions are not the whole truth. We can learn to allow events to unfold without judging them and getting swept away by feelings. It takes practice, for sure.

Thoughts are energy, and we can learn to observe them without attaching to them. Positive thoughts create positive feelings and negative thoughts create negative feelings. We can choose which thoughts we want to entertain and let the others go.

Another good way to change our energy to the positive is to practice appreciation and gratitude. We can find things to appreciate in even the worst day; just look. Even small things can lift us up. We can choose what we want to focus on.

Drawing, too, can change our energy to the positive. When we're drawing, we soon forget everything and enter into a state of peace. Drawing is cleansing and healing. When we return to our life, it's with a brighter spirit.

All of these are ways in which we can lighten and heighten our energy. They are simple practices but require our commitment. They can change our lives.

Now, let's look at how we might lose our footing. It happens to us all, sometimes in subtle ways. But we can learn to find higher ground again.

Julia Talcott

11 True Creativity

"Love what you do. Be meditative while you are doing it – whatsoever it is!"
— Osho

o o o o o

Creativity is making something new and the way to make something new is to be you. We are each unique; that's how we were created. To be creative we need to know and love ourselves as we are. The way to know ourselves is to come to the place of stillness and peace—of oneness. That's where we find our true selves.

We need to be authentic which means being the whole of who we are—the happy and the sad, the good and the bad. We need to share our whole selves even when sometimes we'll be a bit idiotic—that's also how we come to know ourselves.

Creativity comes from our life experience, our own particular insights and knowing. It helps if we live our lives fully and honestly—we're creating from that place. We don't need to think too much to be creative; we just need to dive in and do the work. Diving in is our decision to begin. Ideas come in the midst of working. Shall we do it this way or that? Watch for the moment of insight, then act on it without hesitation. That's what it is to follow inspiration. Toss out hesitation, doubt and worry. We need to be bold.

All artists take inspiration from other artists. Creativity is making new connections between established ways of seeing too. We learn from each other. At first, we may imitate in order to understand and acquire skill or to internalize what's possible. But soon we need to strike out on our own or we'll only make second-hand art. We're more than that. We can set off on our journeys, like pilgrims—there isn't any final destination. The journey goes on, unfolding with each new exploration, one thing leads to the next.

To be creative means to be in the flow of vital exploration. Whatever we're doing, we can throw our whole selves into it. Why hold back? We'll feel alive and excited when we do our very best. We can't know what will happen in advance—we're diving into into the unknown. Who knows what's there? Learn to trust that there are gifts everywhere and look for those gifts. When disappointment or failure comes, and it will, find its gifts too.

We each have our own art journey and life journey. The important thing is to be ourselves and to be happy to be ourselves.

⑫ The Sneaky Voice of Unreason

"Your task is to love what you don't understand."
—Rainer Maria Rilke

• • • • •

It feels like we're moving forward. We see progress in our drawings; we're making discoveries. If we're paying attention, we've even begun to notice the way drawing changes our mind, how it can be like meditation. We're getting ideas for making art or for changing our lives. It's all very exciting. Then a moment comes and, suddenly, everything seems futile. Something crashes in on us like a tidal wave—the sneaky voice of unreason.

Our drawing of Fred looks more like Frieda and we can't believe it! After all our effort, after all the hours we've spent drawing! Or what was meant to be a finished drawing—one we might frame and sell, even—has that stiff, second-hand look. We think, "This is lousy," or worse. We mutter, "I stink! I'll never go anywhere!" How can we think such drastic thoughts? It's our ego mind that undermines.

Our ego mind arises out of the left side of our brain, the seat of language and analysis. It's our conditioned mind—the mind that allows us to construct our identity based on a rational approach to our experiences in the world, good and bad, from childhood on. But our ego mind can be limited. It's sometimes overwhelmed by negative experiences we don't know how to fully process. Maybe it's childhood taunts in the schoolyard, or a parent who disappointed us. Maybe it's a job we didn't get, or a lover who broke our heart. Our ego mind is concerned for our survival and is often a helpful, rational guide but it can also wall us off to protect us from further suffering until we have a deeper understanding.

We all have unprocessed experiences deep within, mostly from childhood when we didn't have the experience to put things into perspective. Most of us get caught occasionally by unconscious urges, at least for a while. We might try to look good at the expense of being authentic. But we can only shine when we're living from the center of who we really are. If we don't know how to process the events in our lives the sneaky voice of unreason can take charge. We need to learn to observe the thoughts that dance through our minds. So now we'll try to identify that sneaky voice and discover who we really are.

The sneaky voice of unreason whispers to all of us sometimes:

—"I can't draw. I haven't drawn since I was a kid."

—"I'm not very creative."

—"Other people are way more creative than I am."

—"I haven't got enough education, money, connections, time etc."

—"I'm confused. I have no idea where I'm going."

—"I'll never get this."

—"This is hard."

—"Picasso is so much better than I am."

—"My teacher said I had no talent."

—"I got rejected by my favorite gallery."

—"I'm not good enough."

On and on.

We know that sneaky voice of unreason so well. He's our kissing cousin. "Who do you think you are?" he says. "Why bother with this?" He wears pants with sharp creases and snakeskin shoes with pointed toes. He looks cool, like he knows what he's talking about, but he's sneaky and sly, too. Sometimes he tells us to chuck our big pad of newsprint away and buy a new pair of shoes like his. That cousin of ours was never up to any good; let's face it. Why do we pay attention to him? The minute you hear his voice, stop. Don't listen. He's the Duke of Deception. His job is to make us feel so bad that we rebel against him!

We don't need to turn away from our dreams. The only failure is turning away from what calls us. We can just draw—just make marks on paper, just learn, just experiment, just see where we are, who we are. We can let go of some of our attachments. Maybe things do not need to be the way we first thought. We can loosen our grip. Who knows where it goes? Who knows the full picture? If we're called to do this, we're meant to do it. That's all. Just carry on and see what happens. If we leave off, it should be in a place of peace, knowing, and happiness, not out of fear or frustration.

The Duke of Deception is challenging us but, when we turn to face him, he vanishes like the thought vapor he is. We can learn to recognize him.

13 Leaping over Obstacles

*"When disturbed by negative thought,
opposite, positive ones should be thought of."*
—Patanjali

· · · · ·

There are many obstacles in life and art: daunting realities of the world, challenging circumstances in our lives, things we tell ourselves. It helps to be able to tell the difference between those things we can control and those we can't.

Sometimes in life we're hit by a tsunami—floods and famines, poverty and war, accidents and illness, loss of jobs and income. Dreadful things can happen to people. These terrible ordeals or losses are fierce but relatively rare in most of our lives. If we're hit by one ourselves we have to surrender and find what gifts might be hidden deep within. A tsunami is a tsunami, not something we can change. It changes us. Resistance only makes it harder. It's the same in drawing or our creative path. When everything seems to go wrong, when we feel hopeless—we can just be with it, notice what's going on, try to find the good and not give up. This, too, shall pass. We're bigger and more capable than we think we are.

Choppy waters, those irksome circumstances that can rock all of our boats from time to time, are sometimes harder to get past. We try to ignore the discomfort of water seeping into our boat, but it's hard to move forward when the boat is sinking. Maybe we have too little time or too little money, we're tired from overwork, our partner is letting us down in some vital way, or our job is frustrating. Maybe we're alone, and maybe we believe, against all reason, that no one can love us. Maybe we're surrounded by so many people, or so many activities, that we can't find ourselves anymore. It could be any human thing. Sometimes we think this is it. How can we patch a boat or hop into a new one when we're out in the middle of the lake? We forget we can swim or abandon ship or change course. Change is always possible. If our drawing is just not right or we feel thwarted in our creative life, we can alter it or start fresh. We can overcome obstacles.

Our own thoughts can knock us over like tsunamis or rock us like choppy water. A thousand thoughts pass through our minds—some throw us into a funk, others confuse us. Our minds are like a river full of fish streaming by, one fish after another. Sometimes we grab hold of one. It's slippery and darts away. Then we catch another by chance and cling to it as if it could take us to heaven. Sometimes we hardly know why we grabbed it because it's not that attractive, to tell the truth, and our higher self knows it.

Part of a drawing practice is to learn to see obstacles for what they are. Most obstacles are in our minds. Even external challenges can be overcome with the mind. Learning how to use the mind is key. Here are a few ways—

● Watch Your Thoughts

We know that to change our energy we can begin to watch our thoughts. It's the same for when we draw or create anything. When we're in the midst of creating, we can watch our thoughts as they show up, see what they are, let them go, and return our focus to what we're doing. It's the higher self that observes, the self that exists beyond the realm of thought, the knowing part of ourselves. It discerns the value of our thoughts, and we can learn to listen to it. Some thoughts are helpful, some not.

In drawing, "Let me put a line here" may be a very useful thought. "I think I'll abandon this drawing; it's going nowhere now" may also be a helpful thought, or not. Our higher self is steady and clear. Useful thoughts leave us feeling steady and clear.

Becoming aware of the higher self is the purpose of meditation and also of yoga. When we're doing an asana, one of the physical postures of yoga, we usually feel some discomfort, even pain, as we stretch. We'll notice this pain and have all sorts of thoughts. Some of the thoughts might be: "This is too hard," "I hate this pose," "I think I'll just ease up on this one." We can tune into our higher self and watch this parade of thoughts to see who and where we are. Do we think everything is hard if it causes us a little pain? Do we stay with things, or do we give up? If we give up, how do we feel? The pain is gone, but then we haven't done anything. Perhaps we feel sad. Perhaps we just don't want to do yoga right now. Perhaps we see how we often give up when things are difficult. This is the purpose of practicing yoga: we come to know ourselves and also to know our true higher self. It happens with drawing, too.

When we draw we enter another state, a right-brain state, our big mind. Still, thoughts arise. We can just notice these thoughts, note if they're helpful, then dive back in.

● Positive Thoughts

We may notice negative thoughts when we look at our work. "This drawing is the worst drawing in the world! It's nothing like I intended!" Even when we think these negative thoughts are justified, even when we think that what we're doing is lousy or hard, we can replace each thought with the opposite positive thought. We might become aware that our thoughts are limiting—some are useful, some are just old habits that are not useful at all. Useful thoughts move us forward.

Patanjali, the Indian yogi from ancient times, explores "threads" of truth in his Yoga Sutras, which form the basis of yoga philosophy and practices. These are meant to lead anyone of any religion or persuasion towards union with the divine, with the Infinite Intelligence of the universe, or God, of which we're all a vital part. He tells us that negative thoughts lead to pain and a feeling of separation, to suffering. They suck the energy out of us and lower our vibration, and sometimes that of those around us, if they're vulnerable. When we notice negative thoughts, he suggests that we replace them with positive thoughts. We need to become alert to our thoughts because they can be so habitual and familiar, like worn slippers. They may feel very, very comfortable. That's the trick—noticing that comfortable, negative thought might well be a disguise for the sneaky thought-devil who wants to rob us of our brilliance. Sometimes we can hardly imagine framing the world differently. The practice is, bit by bit, to notice and replace every negative thought with a positive one. And then to draw.

Sometimes people say drawing or doing creative work is hard. Sometimes it is. But we can tell ourselves that's good. We can appreciate that without challenging ourselves, we don't go anywhere new.

● Mental Discipline

Noticing our thoughts and actively changing them is a mental discipline. We replace the negative with the positive. Over and over. It may feel uncomfortable, even irrational, at first, but discipline means we do it even if we don't feel like it or fully understand how it will change things. Discipline is conscious action, that's all. If we're unconscious, mindlessly repeating the same old errors, we're not free. There will always be the temptation to slip back into old, comfortable habits of mind. Sometimes in trying to process events we will need to discern what feels right for us, of course. But in discerning we'll need to take care not to dive into judgment and negativity. We all have to practice being mindful, being aware—the more we do so, the more conscious and free we become.

● Single-Pointed Focus

In drawing our goal is to be fully present in this moment, watching our hand on the page and slipping into our creative mind. Whatever thoughts or distractions arise, we can just return our focus to drawing. It will soon happen easily, almost without our noticing. We might well get to the place where we don't hear the phone ring or don't care. Single-pointed focus asks that we keep our eyes, hand, and mind on the work before us. We don't chat with our neighbor if we're in a class, or peek out the window when a car honks. We're busy. Single-pointed focus encourages an open mind into which ideas and inspiration can flow. We can focus on what's important in this moment and move forward one step at a time. Forget what's next—just focus on the now.

● Pleasing

In art, we don't aim to please. We aim to forget others' expectations about what we're doing. We aim to forget our own expectations. We're willing to be lost, to muck about, to discover who we really are. We don't need to look good. Pleasing is a prison. It has nothing to do with art. As artists we need to step into our authenticity, which is always pure and brilliant no matter our skill level. We need to tell the truth, however we see it, in whatever way we can. If we're trying to be good or look good, we're holding ourselves back.

We can be so afraid that we're not good enough that we begin to imitate and make only second-hand art that has no originality. We are all unique, and when we make art it ought to ring with freshness and life. Sometimes we must undo the old pleasing habit by taking radical action. We can draw and draw, scribble even, until we free ourselves. When we get out of the need to please, we slip into real ease.

● Nonjudgment

Judgment is the Al Capone of creativity, the indiscriminate gangster of greed, the one who steals our confidence and shoots us down in a hail of harsh criticism. He finds what's wrong. He's a crippler. Al Capone is our small, shadow self. He can be there in all of us. We won't recognize him by the tilt of his cap or the gun in his hand. It will be that sinking feeling in our gut when he speaks. "You're not quite good enough, lady. If I were you, I'd give up any idea of being an artist right now before you make an idiot of yourself. Who do you think you are anyways?"

Wherever we are, we can catch glimpses of what is working and go from there.

We need to discern where we are with strong, clear minds. We do this by recognizing that everything we do is necessary for our journey. Discernment is different from judgment. With discernment, we assess what we're doing as we go, build on what is working, and let the rest go.

● No Force

There's no need to force. For one thing, we don't need to get anywhere. We might have a vision, a destination in mind. That's good. We don't want to be aimless. We do have desires and intentions. But we don't need to grip our desires with steely hands and get there in the next hour. A journey takes the time it takes; we can't always know how long that will be or where it might take us. There may be stops along the way, detours even. We don't need to push our way forward. It's better to feel good, to breathe deeply, to be relaxed when we work. Art isn't about aggression; it's about presence.

When we have a vision for our work, this issue will come up over and over. We come close to realizing our vision but see we've fallen short of our intention. We begin again and try another approach. Again, we fall short. Now we might begin to tighten up and to slip into a clenched determination. It's very important to observe ourselves as we work. If there's steam coming out of our ears, we're trying too hard. When we force, we close the door to inspiration. This doesn't mean we shouldn't work hard. To get anywhere, we need devotion. But hard work is different from forcing; it's steady and clear.

To create we need to stay flexible and open, so we can see clearly. We may well need to start a project over, but we need to do so in a relaxed way. When we notice ourselves tensing up, we need to step back and let go. We need to forget about it. It's the only way to see clearly. When we let go, the answer and even the ability comes.

● Start Over

If something isn't working, we can just rip it up. We can let it go and start over. Not everything we do needs to be preserved. It will not all be brilliant. The greatest value is in the doing. We don't need to attach and hold on when our drawing has veered off course. We can just look and see to understand what's there. When we rip it up, it can be fun to toss the scraps of paper in the air like confetti and to know there's 100,000 other drawings within us. But then, we start over. Sometimes we need to do things many, many times to get what we want.

● Courage

Without courage we don't go very far. In art, as in a life well lived, we're always stepping into the unknown with confidence. We're responding to what calls us—that's why we can trust it and head off on new adventures. We're not acting alone but together with Spirit. We're growing in awareness and strength. We may fail; so what? We may be ridiculed or laughed at; who cares? If we choose the safe, predictable path, the one we think we control, we go nowhere new. We never get to be who we are. Courage is trusting that we're capable of what we're called to do and taking action, even if we don't know exactly where it's going. Every drawing and creative act asks us to have courage. Every drawing gives us the opportunity to step into the place of faith. Faith is ultimately a choice, and we always need it on the creative path, and in the life well lived, because we're going where we've never been before. Maybe we're afraid, it doesn't matter. The way to have courage is to envision, over and over again, a positive outcome. And then to choose faith over fear.

● The Incredible Lightness that Arises from Being

In drawing and making art, we just need to answer the call, show up, and take action. We watch what emerges and discern what works as we develop clear ideas that come from the core of who we are and what our life has shown us. Art is about authenticity. It includes the whole of who we are—the light and the dark, the good and the bad, the yin and the yang. In art we bring these polar opposites together.

We can be where we are. Our goal is to see with clarity and to move towards peace and love. Then we can simply be. We can think of life and art as a fantastic soufflé: nourishing, a bit challenging to make, heartening, sometimes disappointing, sometimes fun, and mostly very high rising. It's something to be enjoyed like a fine wine, or with a fine wine. We don't need to force or control. Some soufflés will flop—it's okay; we can try again. Life and art are bigger than we are but we are a vital part. A little perspective helps. Things happen when we let go of control and enter the flow of inspiration and being.

We can just be with whatever arises and know that it's perfect for this moment. We are who we are, and the right inspiration and work and people will come to us throughout our life. Without this moment the next one can't arise. The essence of this moment and of our thoughts creates the quality of the next one. Drawing gives us a chance to practice all of these things.

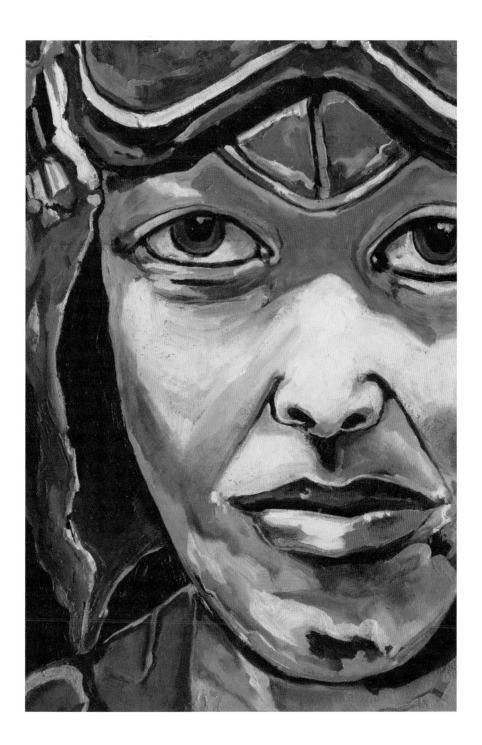

⑭ Drawing as a Practice

"An ounce of practice is worth more than tons of preaching."
—Mahatma Gandhi

.

Drawing is not just about the end result; it can be a practice, like yoga or meditation. As we explore drawing, we may develop goals for ourselves as artists. We'll soon notice the way drawing can bring us fully into the present moment, and this may be goal enough. Either way, drawing is a fruitful practice.

In The Saturday Morning Drawing Club, a woman who had just finished cancer treatment came to join us. She had not drawn since childhood but, right from the start, lost herself in drawing and did wondrous works that surprised us all. Perhaps it was her own recent personal tsunami that gave her heightened focus and courage—her drawings were clear and astonishingly sensitive from the first. One day, she said that drawing had given her such a gift: she didn't think about anything else when she drew; she was just totally present. She found it liberating. This is the place of connection, power, and healing.

It's worth making drawing a practice for the sake of growing our skills, too. We can't find ease or power in our drawing or art making without practice. Neither can we receive inspiration. It's in the practice that we gain the strength, skills, and confidence necessary to do good work. Don't be afraid to do the same thing over and over. Keep at it until you find what you want. Don't stop short of your goal. Work at it. But with a smile.

When we approach drawing as a salutary practice, we're not drawing to create something to put on our walls or even really to get "good" at drawing; we're drawing to be fully present in this moment and to know ourselves as we are—beings of spirit, unique, creative, and compassionate. That's what shows up in our drawings. We can enter the place of peace and happiness every time we sit down to draw. When we know it, we can take it with us as we step into the world.

How to do a drawing practice? Just show up, day after day.

15 Mind Chatter and Thoughts That Matter

"Go with your first impulse. It's usually right."
—Bono

• • • • •

When we practice drawing, we can notice the mind-chatter of our ego. It might show up as our friend, the Duke of Deception, complaining: "This is lousy," or "This is hard." He might also inflate: "This is the most brilliant drawing ever," and "I'm the next Picasso." We don't want to be Picasso; we can't be. It's our goal to know and manifest our own authentic selves. Mind-chatter can also simply get caught up in the mundane: "I'll have a turkey sandwich for lunch," or, "I really want a haircut like Sally's." We let go of all these thoughts. We don't need to follow a single one of them. The beauty of drawing is that, if we're focused, we won't want to follow.

But that doesn't mean that thinking doesn't come into drawing. Even when we're drawing on the right side of the brain and are not in our verbal, linear, analytical minds, we do still need to think in a cool, rational way. The reasoning mind is also a very important part of who we are and how we move forward. It's good to remember that the door between the two sides of the brain is open and that we'll go back and forth. We're learning to watch our thoughts from the space of our higher self, discerning the ones that are big-mind thoughts and letting the others go. Much of what happens in drawing is not thinking but a spontaneous "knowing." It all happens so quickly, it can often feel as if we're guided and simply making marks in a spontaneous way. But there are moments in drawing, and in all creative work, when we need to make clear decisions. We need to pay close attention as we go along, to discern where we are and what the work is.

It's good to keep it light and wait for clear direction. Some of our decisions will come from assessment and some from pure inspiration. But our thinking minds will have posed the question of what to do next.

Sometimes we see there are several possibilities. Shall we do this or that? Yes or no? We can pause and remember our intention. The trick is just to notice and not think too much. Usually pausing and taking a breath is enough. Intelligence seems to reside in the hand, too, and often we just dive back in.

Some of us have so much trouble making decisions, we become almost para-

lyzed. We can get into this mindset when we think too much or care too much. We're afraid we might muck it up or make the wrong choice. There are no wrong choices. Just choose something and give it a try. If it doesn't work, just start over.

Worrying over a decision only stops us in our tracks and takes us out of the flow. Not making a decision can lead us into the swamp of stagnation. The funny thing is every choice will teach us something and take us somewhere. But we don't want to slide off into the swamp—it can be so hard to tromp back out again.

For some people drawing and art making can be a way to express feelings. Even so, it's important to step back and discern what is being expressed, so that the viewer can also participate. If it's all feeling and no discernment, the work is likely to be so personal that no one knows what we're talking about. Some people may use drawing simply to express feelings with no intention of showing the work to others. Still, it's important to see what these feelings are and what they're telling us about where we are in this moment. Then, it's a useful practice.

We don't need to second-guess ourselves; just keep going. If we're practicing one-pointed focus, our minds will be clear and decisions easy. They'll come as a sudden knowing rather than through endless reasoning. But our reasoning minds will say, This is what I'm doing, and this is why. It helps to be clear.

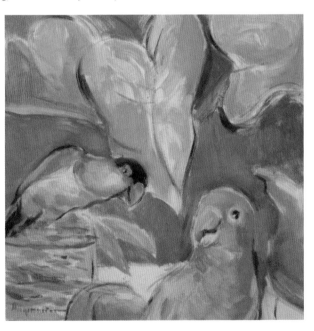

16 Looking and Seeing

"I shut my eyes in order to see."
—Paul Gauguin

• • • • •

When we make a drawing or a series of drawings, we can then look and see what we've done. How do we look at our work and what are we seeking?

In The Saturday Morning Drawing Club, we mostly do several drawings in succession before we spread them out on the floor to study them. We then parade from one artist's work to the next, from the first drawing the artist made to the last. If you're working alone at home, you can do the same with your own series of drawings.

Our practice is to speak about what we love or find interesting in a drawing. We don't utter a word of criticism; we are not here to critique. Even if the artist fails to make an accurate observational drawing, there's nothing "wrong." Everything is part of the journey of discovery. What's helpful is to notice what's working, so the artist can build on that. The idea is that building strength overcomes all weakness. The things that don't work are usually quite obvious: an eye off to one side, a forehead too large. Sometimes these distortions have a magical expressiveness about them; sometimes they just look like mistakes. We can look and try to make that distinction. Occasionally, we'll mention that forehead, but only after noting what's strong and interesting. There's always something strong and interesting if the artist is fully present. As stated before: what we focus on grows.

If we're approaching what we do with any degree of seriousness, we do need to take a good, hard look and see where our work is unclear and why. Sometimes, our skills are still growing; sometimes, we've not had a clear intention or maintained a consistent approach. And sometimes, we're asleep at the wheel. We need to look and take note. We may pick up immediately how we've veered off course, or we may need to take some time to study what we've done. Yes, that forehead is too large. The thing to remember is this: it only means the forehead is too large; it does not mean that mistakes are bad or that you, as an artist, are hopeless. Far from it. We just need to notice what's there. We can't grow without honest assessment.

If we're working with others, we need to take care before speaking. Sometimes,

it can take a few moments to see what the artist is doing, bit by bit, drawing by drawing. Sometimes, the artist is not fully conscious herself of what she's uncovering—it's all so new. We speak softly because it takes courage for artists to share their work, especially when some have long years of experience and others have almost none. The experienced artist, too, is on a journey of discovery. It may be harder for this artist to take chances, to get out of habitual patterns, to make wondrous mistakes.

Some of our drawings will look like cow manure—it's true. It does happen. All days are not equal. All drawings are not equal; we needn't fool ourselves about that. It's okay. Sometimes, we have an off day. Sometimes, we don't slip into presence. We're human. We can simply notice.

It's important to look for the artist's intention or our own intention. Sometimes, we have to ask. Did the artist intend the high forehead? Maybe the artist was just blundering around in the dark. Sometimes, it's necessary to blunder around. We should encourage blundering. The artist might be aware she's blundering, or not. Perhaps she just lost heart halfway. That, too, is okay. It happens. We don't always fully know what we're doing. We can ask the artist to say what she sees, how she feels about this drawing.

We can also look at the way a series of drawings progresses. Does each drawing become clearer and more assured? Did it occur to the artist somewhere in the midst of things what it was she was looking for? That is often the case. We're always working with something: contrast, balance, rhythm, movement, pattern, emphasis, unity. And we're also working with color, value, texture, shape, form, space, line. Not to mention our heart and mind, our experience and spirit. We look for the artist's presence in the drawing, and for clarity of vision and technique.

We look for consistency. Did the artist make the whole drawing with the same approach to line and shading? Consistency allows the viewer to see what the artist intends and to trust the artist knows what she's doing. It's good to think about how we might bring greater clarity to a drawing.

We listen to what the artist says and to our thoughts about our own work. What do we feel when we look at it? Are we excited? Does our drawing surprise us? Work done with full presence is always surprising, at least to some degree. If we're just going through the motions, there won't be anything fresh in our work.

It's good to spend some time looking: the more we look, the more we see. What we see may not have occurred to the artist or even to ourselves until this moment of careful observation in the company of others. This is why it's helpful to work in a group—we

each see different things.

It's not always easy to speak about visual images. Art communicates directly with our unconscious mind, with our hearts. It's beyond the full grasp of words, but still there are still things to say, if we take time to look and to allow impressions to coalesce into insights.

Our comments give the artist something to consider as they move forward. If we're making observational drawings, we can note the character of the artist's hand. It doesn't matter whether the drawing is accurate or not. We're looking for presence and intelligence.

We hope to find something fabulous and unexpected in a drawing that turns us on to the wide-open field of possibility—a swash of brilliant color, the snaking of a thin line, feathery shading. There's the moment we forgot ourselves, the moment our hand went its rakish way. Hallelujah! When we discover something fabulous, it will show up in our next drawings.

Looking and seeing, we gather strength and insight for the journey ahead. We see what interests us, what our particular gifts are, and who we are. We need to know ourselves to move forward.

17 Making Friends with Mistakes

"We can only be successful if we're willing to risk failure."
—John Assarof

• • • • •

Mistakes happen. Our drawings don't always look like we planned. All this practice, all the good intentions, and nothing but an odd mess on the page. It's the way it is sometimes. We're aiming for one thing and something else shows up. But take a good look; this might well be the point of departure. This might be the point where something brilliant breaks through. There's often more life in our mistakes than there is in our careful, controlled efforts.

Matisse sometimes left errant lines in his drawings. He drew right over them and knew that the strength of the new line would overcome the weakness of the one that veered off course. He knew it didn't matter.

One day we draw well and with ease, another we don't. It depends on our energy and focus: how much sleep we got, what we ate for breakfast, a hundred other things. It depends, too, on our skills and the clarity of our intention. It depends if we've seen the white light towards which we're headed, or if we're just fumbling around. Or maybe we're determined to look good with this drawing, and we clench up. Trying too hard will do it. Clinging to desires will, too.

Too often we hold ourselves back, fearful of making a mistake, and don't go far enough. We don't want to "ruin" what we've started and choose the path we've already taken a hundred times—the one we're pretty sure will work but, this time, for reasons we can't yet see, it doesn't. There's no life in this work, no courage. We hesitate to go to the places we've never been before, just for the sake of going there. Our work grows stale, and we become bored. We might even give up.

Mistakes look like a mess, like failure, but they open the gate to possibility. We need only take the time to look, give them our full appreciation, and whisper a humble word of thanks. They have genius in them.

We need to take chances in art, just as in life. We need to make a mess. We need to be willing to do drawings that we'll rip up—lots of them. We can take calculated risks or wild gambles. Even when the chances we take catapult us to the place of uncertainty and awkwardness, nevertheless we're in motion, engaged in the dance of intention, action, and inspiration. Only this time our intention isn't tethered to the ball and chain of inhibition. The only real mistake is trying to avoid mistakes and failing to dip our toes into the Sea of Uncertainty.

Once, in The Saturday Morning Drawing Club, one of the members said she loved that I, the teacher, drew right alongside everyone and that some of my drawings were total flops! It's true. Not only do we learn most from our mistakes, they can make other people feel good!

Mistakes are our friends. We don't go far without them.

Cat Bennett—left and bottom; Maggie Stern—upper right

Cat Bennett

⑱ A Sketchbook for Life

"Je suis le cahier." (*"I am the sketchbook."*)
— Picasso

● ● ● ● ●

Now we've been practicing for a while we'll want to get a sketchbook, not just to make observational sketches but to hold our inspirations and explorations. We can invent, design, record, and explore in our sketchbooks and pour our hearts out, too. We can draw, paint, and write. We can paste things into it that we find on the street. The sketchbook is a messy, amorphous friend. It's a place where we can be ourselves, note where we are in this moment, and see more clearly what's within us and around us.

It helps our art to be attentive to what interests us. We can observe the world around us and draw it. We can record our confusions and broken hearts, the waves of sorrow that occasionally wash over us, the waves of happiness, too. The sketchbook is a place to ask questions we haven't asked before. Our thoughts and preoccupations will be visible. Some of us will use a sketchbook for making observational drawings. We can carry it with us and draw what we see as we go about our lives. It gives us a chance to observe with care at any time. It can be a visual diary of our life or travels, a way to remember, savor, and see with greater clarity.

Sally Young—Travel Sketchbook / France

It can also be the place where we incubate ideas, where we scatter seeds and notice what takes root. We can jot down ideas and sketch them out. One idea always leads to another. Art is always conceptual.

We can use our sketchbook to design things. We can make preliminary sketches of the small sculpture we plan to make from the odd objects we've found on the street. We can see what they might suggest if assembled into something new without getting out the soldering gun or the hammer and nails.

Leonardo's sketchbooks are so full of wondrous ideas and inventions that what remains of them is in publication almost 500 years after his death. His sketchbooks are filled with studies from nature, as well as ideas for inventions. They explore anatomy, mathematics, geometry, astronomy, botany, zoology, and the military arts. He practiced drawing in them, amplified his understanding of the natural world, discovered how things work, noted ideas, and designed inventions like flying machines that were far ahead of their time. His sketchbook was a place for visions. He wrote as well as drew; even more interesting, the words are backwards, so they can only be read with a mirror. No one knows why. Perhaps he felt the ideas were so heretical that they must be kept secret. After all, he invented a flying machine, and who believed in airplanes in the 16th century?

As artists, it can be helpful to carry a small notebook with us—ideas come at odd,

sometimes awkward moments, especially when we're in the midst of a project. Our note-book can be a place to solve puzzles; without thinking too much, we can just draw and jot down ideas. It's a place to leave our analytical brains and enter the soft, free-floating mind of creativity.

Our sketchbooks can be messy and really ought to be. If we take too much care it's not a sketchbook but a scrapbook, something precious, something else. If we take too much care, something's getting in our way—perhaps a sense that it needs to be this way or that, or that someone's looking over our shoulders. The sketchbook is ours alone, a palace of indulgence and imprudence. It's not a place for care. It's a place for careless explora-tion, a place to be free, a place to shed our polite constraint, a place to live large. It's also a place to step into the deep shadows of the unconscious and watch for the play of light.

Our sketchbook is a place of total nonjudgment. We can love everything in it, even the place of confusion and the place where we took the wrong turn. We can appreci-ate the way our pencil slipped or the tea dripped. Everything can give us ideas.

We don't need to pay too much for a sketchbook; cheap is good. If it's too pre-cious we might feel inhibited. It would be like brushing our teeth in a party dress: we might be concerned about ruining our dress when toothpaste dribbles from our lips.

In our sketchbooks, we can think about what we know to be true and how to express that in our art and in our life. When we hold it in our hands, we're holding a new life. A sketchbook is an art incubator, a holy thing.

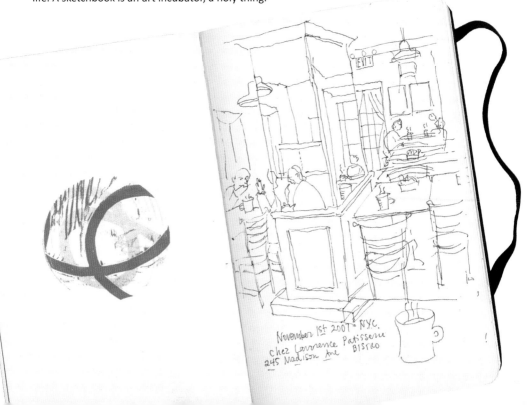

(19) Writing Our Way Forward

"Speak honestly."
—Sachiko Adachi

.

Writing, too, can help us explore and discover. We make drawings in our sketchbook, but we can also write to uncover ideas, ask questions and set our intention. We might want a separate journal just to write in. We'll get to know ourselves better and find out what we want to do with our art and our lives.

In her book, *The Artist's Way*, Julia Cameron suggests that daily journal writing can be a way to clear the decks before we begin our creative work. If we write first thing in the morning about whatever is on our minds, we get to release the emotional charge and free ourselves up for the work that lies ahead. We also get to process whatever is puzzling us in an attentive, focused way. But if we linger too long, writing about our lives will become our focus rather than the drawing and art making that awaits us. Drawing itself will take us out of our daily concerns, but writing first can help us see more clearly. We need to just tell the truth; wherever we are is fine.

We can clarify our intention. Creativity is change, the making of something new. We need to stay open in the process of creating to whatever might come to us but it's good to start with clear intention. Writing down our intention for our work helps us keep the work pure and helps us notice when great ideas arrive in the midst of working.

We can use writing to make notes and puzzle out possibilities when the time comes to reflect on the work we've done. We can pose questions. How do we feel when we look at the work? Does the work fulfill our intention for it? Is there anything in it that didn't work? What changes might we make to improve it? Did the work open us up to new possibiltities? How will we bring it into the world? Can we think of new ways of birthing it?

There are so many questions we can ask. Some are challenging, but worth asking. When we start to write about our work, we're taking it seriously. Drawing can just be for fun. It can just be a drawing practice that offers the benefits of bringing us into the present moment and connecting with our true selves. We needn't ask more of drawing than the peace and happiness it offers. But, for some of us, drawing may just be the starting point for other artistic endeavors.

If we're growing as artists, we'll soon notice the way creativity enters the whole of our lives. Through writing, we can explore how we can make our lives art too. The same principles apply. We need to listen to what calls us then set down our intentions clearly on paper so that we can read them over and over. Our thoughts help to create our reality so keeping in mind our highest intentions for our life and our work will help manifest the results we want.

We can't be creative if we're clinging to predetermined ways of making art or set ways of living. We need to be flexible and open. In that place, all sorts of inspirations will come and often in the midst of writing. We need to open up to possibilities and get comfortable with change. Sometimes change is unsettling and we might wonder if we're heading in the right direction. It's okay if we head off on a few dead end jaunts—we can turn around when we see the end. By exploring our feelings and our direction in writing, we'll come to a place of peace where we can receive more.

Not everyone needs to write. Some people just get on with whatever it is they're going to do. Others have to puzzle things out and explore possibilities with words. We can build energy by writing about the good things we're doing and want to do. We can read our writing journal to get refreshed. When we look back at it, after a period of time, it can be surprising how many of the visions for our life and art, that we first scrawled in a notebook, have now come true. Give it a try and see.

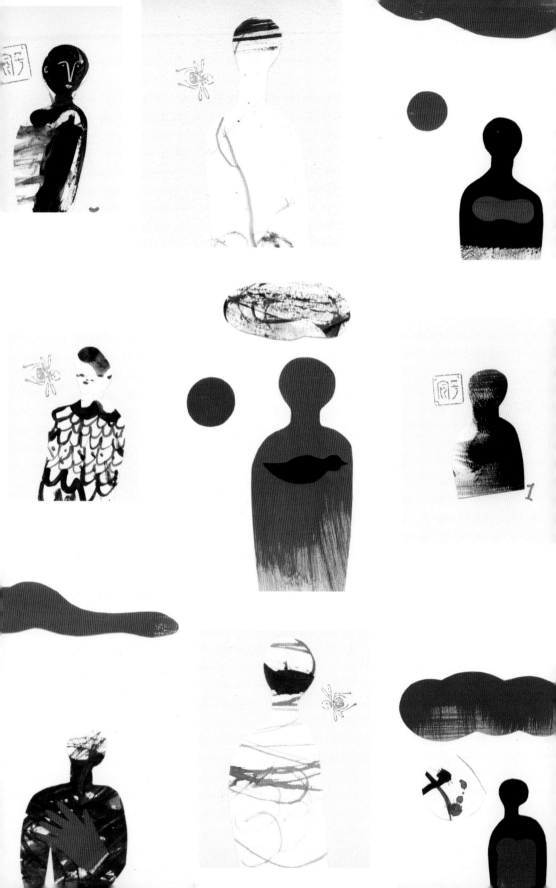

20 Being True to You

"Be yourself; everyone else is already taken."
—Oscar Wilde

● ● ● ● ●

It's worth remembering Picasso's famous dictum: "Good artists borrow; great artists steal." We want to be great artists, whether or not we're ever known. A great artist takes inspiration from others but stays true to oneself. A great artist is not afraid to be naked. Or afraid to be seen. We can just be who and where we are. Have you ever noticed how much compassion you feel for someone who is telling their story in an open, truthful way? It's the only way we can really connect with each other. And it's the same in art.

Drawing asks us simply to be ourselves. That's all. Whoever we are, wherever we've been and have arrived at, drawing is asking that we tell our truth and stand naked in front of each other. No matter the wobbly line—it's honest and true. The slick, unconscious line is not. The lazy line is not. Nor is the imitative line. Drawing is just asking us to show up and bring our presence into every moment and action as we are.

The danger is that we can hide behind the veneer of correctness. Getting it "right" can seem like the way to go but no one can find us or know us through our work. It might make us feel like we're doing well but we share more when we let ourselves be.

We might ask: Who am I? What are my deepest convictions? What am I here to express and do? These are big questions and can only be answered over time, as we grow in awareness. We're growing and changing all the time. But our real job is just to be ourselves at any point in time and to come to know our true selves, our inner being, which is brilliant and good. We can take inspiration from other artists. Think what it is about the work that inspires you, then bend it to your own purposes. Change it—radically.

It takes time. We've all donned cloaks of phony respectability or outrageous rebellion at times in our lives. We've hidden our hearts so they wouldn't be broken. We've gone along with things we didn't care for. We've overridden our inner knowing, some of us more than others. Now we can just be ourselves. In drawing, we let those cloaks fall to the floor and stand naked in front of ourselves and others. Even if our knees shake with uncertainty, it doesn't matter. We will discover our goodness and beauty, and others will too. We'll discover who we are and shake off all the other stuff.

Cat Bennett

21 Hot Desire and Cool Intention

"You are what your deepest desire is.
As your desire is, so is your intention.
As your intention is, so is your will.
As your will is, so is your deed.
As your deed is, so is your destiny."
— Upanishads

· · · · ·

Desire is the starting place for intention. We feel excited and want to do something. We want to draw all day. We want to make a painting 10 feet tall and full of color to hang in a grim government building. We want to film artists around the world to find out what they're saying about the environment. Without the heat of desire we wouldn't do anything.

Desire comes from our lives, from what we see, from experiments and explorations. It comes from love of life. And it comes from inspiration. When we feel the desire, then we can clarify our intention for our art. Clarity is cool, a result of detached, analytical thought. We try to understand our desire and consider the ways forward. We need to think things through with a cool head.

Our intention might have to do with technique: we'll draw with tiny broken lines that express the energy of our hand and the way we see nature. Or it might have to do with materials: we'll draw in red paint only for the passion and excitement it conveys. Or it might have to do with subject: we see the Arctic is being threatened by an oil pipeline and know we must record what is left of the natural environment. We'll have our own reasons for our intentions.

The Italian artist Giorgio Morandi (1890–1964) painted bottles over and over again, alone and in small groups, clean and covered in dust, in light and in shadow. He came to know bottles very, very intimately—their shapes and what they might hold; the way light passes through them; the way they stand up with dignity even when alone; the way they rub shoulders in a companionable way with bottles of other shapes and sizes, even other purposes; how dust does not detract from their forms; how the shiny ones are no more impressive than any others. He has shared so many perceptions with us through this simple and long devotion. Morandi understood that worlds of insight can be revealed

through a simple intention: to draw and paint bottles for what they might say to us about the nature of life. His intention was grounded in the cool, simple choice to say something about the nature of living as he experienced it.

With time, after experimenting for a good while, after swimming upstream, and driving our cars into muddy ditches, after spraining our ankles leaping small fences, and catching cold walking on country roads on rainy days, we'll find the route we want to take. Without clear intention our work will feel muddy.

In great work, we need time to apprehend the fullness of the experience. But we know, even if we can't fully explain, that we've encountered something worth studying, and we can say something about what that is. It takes all artists time to find their purest offering. Gauguin left the buttoned-up grey sobriety of his native France in a fit of despair. As an artist, his original intention was to wash away the drab limitations of the society into which he was born. At first, he did this by painting his countrymen in somber tones, hunched and frozen—the constricted suffering of the French culture at that time. Only when he reached naked, sun-drenched Tahiti did he find the inspiration that washed away the somber stuffiness of bourgeois European society. His earlier artwork, competent as it is, didn't have half the power of the later Tahitian paintings, where he painted the transcendence he found in the simple expression of sensuality. But Gauguin kept his intention clear, and new opportunities and visions came to meet him.

French artist Manet—also living within the constraints of a repressive and judging society—painted a prostitute assuming the pose of Olympia with such beauty, wit, and respect that it trounced bourgeois values. In contemporary England, the graffiti artist Banksy splashed the word BORING in red paint across a vast, windowless, concrete, corporate wall to challenge pervasive contemporary business power. Art comes from the place of our most passionate realizations.

Our intention can be as simple as—I'm going to paint two gay men in the shower to declare myself as a gay man and to bring honor and sweetness to gay life. That's what David Hockney did. It only needs to be deeply, truly authentic to us. We need to care, and also to pay attention to what we care about.

22 Inspiration Knows Your Name

"Inspiration exists but it has to find us working."
—Picasso

· · · · ·

After practicing for a while, we've begun to notice that our drawings often surprise us. They're more brilliant than we imagined they could be! We're getting all kinds of ideas. We could draw maps of our imaginations. We could draw portraits with our eyes closed after spending a half-hour in conversation with our subject. We could send sketchbooks all around the world and collect drawings from people living in vastly different circumstances. Or we could start a drawing club for kids in the inner city. When we're inspired, we're breathing in spirit, energy and ideas. Inspiration comes to us when we get out of our thinking minds and slip into silence. It comes to us also when we draw.

How do we recognize inspiration? How do we know it isn't just another wobbly thought? Inspiration comes from the realm of pure potential, from stillness, just as the call to make art does. It darts in between our thoughts. Concerted thought is hard; inspiration is easy. Inspiration seems to come out of nowhere and takes us to a new place. We recognize it as true, even if only for an instant. We feel excited, humbled, and happy. We want to take action.

Thinking is a logical progression of ideas; inspiration skips the steps. If we're locked in the analytical left brain we may not remember to open up to other ways of perceiving. We might feel anxious or certain of our "rightness." Inspiration is soft and without doubt. It feels like a gift, but not one to which we need to cling.

Inspiration comes when we assess. We must use our rational, thinking minds for taking stock of where we are and what we intend to do. When we ask good questions, we receive good inspiration.

Inspiration may come in the midst of drawing or just sitting by the window with a cup of tea. It may come when we're driving the car or when we're drifting off to sleep at night. It comes when we stop trying. It's that certain flash of knowing of what to do next that quickens our pulse. The inspiration that comes to us is equal to our devotion and to our experience.

Drawing trains us to open our minds—to get out of the way of the cascade of

Yuko Adachi—Labyrinth

thoughts and act on the inspirations that sneak in between the thoughts when we're in the place of peace. Whenever we sit down to draw, we get a chance to open up. Sometimes we pause for a moment, look, wait, receive a sudden knowing, then dive back in. If we trust the inspiration, we move forward with ease. Sometimes we don't need to pause: the inspiration arrives in the midst of action, and we follow it. Drawing is great practice for receiving inspiration.

Sometimes an inspiration comes, and we wonder if we can do it. We've never done anything like it before. We think this one must be meant for someone else—someone more advanced than we are. If inspiration comes to us, it's meant for us and not for the dude next door. Inspiration knows who we are; it knows our name.

So, what shall we do when it arrives? We need to take action immediately! It's important not to hesitate. There's no point analyzing inspiration; we're meant to trust it. If we wait around and ponder, our mind starts to play tricks on us. Shall we do it like this or like that? Should this be green or purple? It just gets harder. If we don't dive in, if we make a million excuses for why we can't begin, it becomes almost impossible to get going. We lose the pure energy.

Sometimes, we can't believe what the inspiration is asking of us. We think of a hundred reasons why we can't take action. Our excuses can seem so reasonable: we aren't skilled enough, we aren't brilliant enough, we haven't the time. We're afraid. Procrastination is like wearing leg irons in the 100-yard dash: we'll be limping the whole way once we start. It's better to jump when the starting gun is fired. Just leap up and go. Sometimes it helps if we think it's a bit of a race. The best starting gun is inspiration. Believe it. As the great rock musician Bono said: "Don't second-guess yourself. The first instinct is the right one."

The inspiration that comes to us changes as we move forward in our journeys as artists. It comes according to our devotion, to what we're asking of ourselves and of the work. It comes in alignment with our skill level and our ability to execute it. If an idea comes to us, we can do it.

Sometimes the inspiration seems impossible. We'd really not considered making 20 books of drawings with ideas for peace and delivering them to 20 leaders of countries suffering conflict. Can such an inspiration really be addressed to us? And what will we do with it? How will we deliver these books? Is it worth figuring out? We cannot imagine—yet. Inspiration is often a puzzle and a challenge. We're excited by the idea, thrilled by it. We feel the results would be wondrous and valuable, so we begin. That's all. We just dive in

without knowing anything. Everything we need will come to us.

When we rely on our analytical minds alone, we can get confused and muddy-headed. We know this feeling. One moment we're in the lap of luxury at The Ritz, the next moment we're bedding down at a Motel 6. We have no idea what happened and wonder if our mind is playing tricks on us. For some of us it feels almost like treason, we've come to rely so heavily on our thinking process. But to receive inspiration, we have to let go of ourselves and have faith.

Even the most intelligent among us is limited. Indeed, for those who are most gifted in logic, yielding to inspiration may be especially difficult. We're human and can't know the whole. The late Japanese artist, Sachiko Adachi, pointed out in her book, *To Be As We Are*, that we receive inspiration when we get out of the way of our egos. Our rational ego mind often doesn't believe in what it doesn't know. It relies on established data, on what's already been done or is evident—it often trusts only itself. We think reason will keep us within the parameters of safety. Sure, it can fix the car, but it can't give us wings.

It's not that thinking doesn't come into it. As noted, there's a time for appraisal and decision-making in the midst of drawing and afterwards. Our reasoning minds are very, very important in the process. We need to bring the whole of ourselves, and our experience, to the work. Creativity is a dance of reason and inspiration.

We can ignore inspiration—many of us do a lot of the time. We don't believe we're ready, even though inspiration would not have tapped us on the shoulder if it didn't know who we are. Still, we carry many feelings inside, so many discouraging, disabling emotions that we sometimes don't see clearly. The Duke of Deception. That guy, again. Saying yes can be tough until we begin. Some of us never say yes because we feel anxious or uncomfortable. We can just say yes, anyway.

Sometimes, though, the well appears to run dry. Nothing seems to be coming. We're working and working, running in circles. It's time for a rest—time to let go. Everything in life moves in cycles—our creative life too. Sometimes we need to reclaim ourselves, find our center again. Breathe. See what interests us now.

We can't see inspiration when we're stressed or straining, when our mind is cluttered with debris. It may be knocking, but we won't hear it. We need to connect with the stillness within to receive it. Drawing can bring us to this place, just making marks. Meditation can bring us to this place. Yoga, too. Sleep helps. Fun. Love. It's good to have a daily practice to connect with Spirit. Gratitude helps.

And what if an inspiration seems crazy? Like drawing The Buddha on the walls

of The Bank of America? What then? This may be just the thing to do, or not. When doubt arises we can slip back into silence, to the place of knowing and feeling, without judgment. We can wait for certainty. Only then, if the feeling is still pure and strong, do we take action. Thinking will come into it. We can ask ourselves: Will this act create good energy or will it cause pain? The higher purpose of the artist is to contribute to the unfolding of consciousness, and sometimes this involves challenging preconceptions and creating uneasiness. But sometimes foolishness and arrogance disguises itself as inspiration. We'll see that inspiration has clarity and awareness in it. There is kindness too because it comes through our higher self. It is never destructive but it can take a tough stance that forces the viewer to see themselves or the world in a new way.

To receive higher inspiration, we can tune in to a higher vibration. We can breathe deeply and let our thoughts go. We can meditate. We can ask ourselves if we're developing negativity around any person or around something we have to do. We can try to let it go. Often our greatest teachers are the people who seem like thorns in our sides, the ones who make us feel most irritated. They're giving us the opportunity to learn to be with life in all its permutations and to understand our own feelings. We can learn to find the good in all people and all situations. We can practice appreciation, finding something every day to appreciate in our lives. We can practice gratitude. All of these things help us raise our vibration to one of peace, love, and happiness. We all slip from time to time, but it gets easier as we practice.

Inspiration knocks, but it doesn't knock us out. It doesn't force itself upon us. It waits patiently for our attention and never gives up on us; it's we, who so often give up on it. We don't believe it's intended for us, or that we're able enough to act upon it and do the wild and wondrous things it asks us to do. We can turn our backs on it and knock ourselves out for years, insisting it's not possible that we can dance or draw or sing, even though these are the very things we feel inspired to do. We make excuses. We need to study for years first. Or have a whole year with nothing else to do. Or have a lover who knows how to dance the rhumba. Or we say it's too hard. We furrow our brows as thoughts shoot through our heads like poisoned darts. Inspiration unmasks our wounded ways, so that we can heal and become whole again. Gentle action is the healer. We don't need to force. Not all inspirations are huge, but they're all fantastic. In time, we might even realize that every inspired thing we do, big or small, is a gift to ourselves, and to others.

Deborah Putnoi

23 Quantum Leaps

"Having confidence that you have prepared well, get out of the way."
—Trungpa Rinpoche

• • • • •

Sometimes we think that progress must be slow and incremental, but in The Saturday Morning Drawing Club we discovered this isn't so. All of the artists made quantum leaps. The Latin word quantus means "how much." In physics, a quantum is the smallest unit of measurement possible, an indivisible unit of a particle. Quanta are related to both energy and the momentum of elementary particles of matter. In everyday parlance, a quantum leap is something momentous and huge. In his book, *The Spontaneous Fulfillment of Desire*, Indian-American physician and spiritual teacher Deepak Chopra describes it like this: "A quantum leap is a change in status from one set of circumstances to another set of circumstances that takes place immediately, without passing through the circumstances in between." In describing the activity of an electron orbiting an atom, the electron can absorb energy and jump up to a new orbit or release energy and drop to a lower orbit. Science tells us that the electron does not move through space to arrive at its new orbit—it's just suddenly there.

The same principle applies to drawing, creativity, and life. Our lives and our art can change in a nanosecond, and for the good. Suddenly, we're in a new, more wondrous and expansive space. We hardly know how we got there. But just as we can leap up, we can also stay in a holding pattern or drop to a lower orbit. If we're stuck in our journeys, we need to learn to observe our minds and our mental attiudes with greater care. Sometimes we do come to a resting place but that is different than being stuck. Resting is a peaceful, happy condition; stuckness has misery in it.

So what is it that allows us to make a quantum leap into a higher orbit? Scientific evidence suggests the more positive energy we absorb, the freer, clearer, and more assured we are. The more action we take, the higher our energy will be. We can prepare ourselves to make quantum leaps even when we don't know exactly the form they'll take. We need to work hard, of course. The leaps we make are equal to our devotion, our energy and our purpose. As we discussed in the chapter on energy, changing our thoughts to the positive is one powerful way to catapult ourselves into another orbit where we get great inspirations.

Let's now look some other practical ways to make quantum leaps in our drawing and in our creativity:

Work Big

Working big gives us a chance to shed our shyness and step into our boldness. When we're in the deep end of the pool, we have to learn to swim or we'll go under. In the shallow end, we can just paddle around and look like we're swimming. Drawing on huge paper—maybe five feet wide and taped to a wall—is jumping into the deep end. We learn a lot when we need to take our work seriously.

Exaggerate

We can exaggerate whatever it is we're doing in our art, just push it to the next place. This means that, first, we have to see what we're doing. We're drawing shapes, light and dark, something real. What if we push the shapes farther, even distort them? What if we make the light lighter and the dark darker? What if we consider all the things we might do with the object or person we're drawing and choose one aspect that we can highlight or mine to create a deeper, richer experience? Exaggerating our work helps us to break into the awareness of possibility. If we exaggerate we see more clearly, and so does the viewer.

Buy Pricey Paper

Sometimes it's good to use a thick sheet of pricey, crisp, white drawing paper, the kind an artist of repute would use. We may have a reputation, or none at all. Either way, this is our drawing practice. We may not produce a masterpiece, but we can still use costly paper. We can note if our pulse quickens when we look at this paper, or if our mind goes blank. These things can happen when a sheet of expensive paper sits before us. But we can just begin, as if it was nothing. We can focus on what we're doing and forget the expense, which is really just forgetting ourselves and acting with confidence. The pricey paper will bring us forward into boldness.

Rip It Up

After we have had a drawing practice for a while, we notice that our skills are improving. We can do much more than we could before. Many new ideas come to us in the form of inspiration and also from our reflections, as we spend time looking at our drawings. But sometimes we begin only to have everything skid out of control. Midway, we sense

we're heading nowhere. Our focus is broken, and we get that sinking feeling. Rip it up! Rip it up, and think of something new. There's no need to attach to our ideas—if something isn't working, try something else.

● Kiss Perfection Goodbye

We can let go of the need for what we think is perfection and simply explore. We can let our humanity show up on the page. We can draw with our uncertain hand and still make something raw and real, possibly moving, even transcendent. We can take the pressure off ourselves by allowing things to be as they are without pushing for more. It's okay to be just where we are. That's how we move forward.

● Let Go of Control

When we've been practicing for a while, we come to know what we can do. We know our tools, and we've developed our skills over many hours of practice. This is the point where we can let go of control—of the effort to achieve a certain result—and allow surprise. That's the thrill of making art. We're co-creating with everything that's gone before, with the Universe, with the pure energy of the moment. The thrill is when we meet what we've never met before. The thrill is when we step outside our need to control and allow the unknown to emerge—something fresh and alive and new.

● Say Farewell to Intimidation

We make comparisons all the time. We compare our fledgling efforts with the fledgling efforts of others, and with the work of great, famous artists. It's a human thing, the way we are, part of the rational, left-brain thinking that has helped us develop our identity since childhood. Sometimes our neighbor does something stunning, and we see our own effort is weak and confused. Sometimes we've drawn for two months—a few times a week for an hour or so—and we compare our drawings to those of Matisse. Then we find our work lacking! It's funny. So we can note our thoughts and erase all the "no good" ones. They do not serve us. We're on a journey. This journey may lead us to doing fine work or it may lead us to living more fully and kindly. That's all. If we want to compare and contrast, we can note what turns us on in the work of others and what turns us on in our own work. That's the way to do it.

● Breathe Deeply

We can breathe deeply before beginning. We can become conscious of relaxing and letting go of tension and worry. Breath is energy. When we hold our breath, we tighten up and hold ourselves back. If our breath is shallow, our life will be, too. When we inhale deeply, we're breathing in vitality. We are literally connecting with "inspiration." We can go for a walk outside and breathe fresh air. Spiritual teacher Eckhart Tolle says: "All true artists, whether they know it or not, create from a place of no-mind, from inner stillness." Yoga teaches that being at one with our breath is a way to get to that stillness.

● Be Honest

We don't need to puff ourselves up or tear ourselves down; we just tell the truth and show up as we are. When we look at our work, we can describe how we feel about it in an honest way. If we're disappointed, we can say we're disappointed and why. If we love what we see, we can say we love what we see and why. Life becomes so simple when we tell the truth. Things are as they are; we are as we are—just here, naked, vulnerable, open, a little rough around the edges or very rough, brilliant in a thousand ways or more. That's the truth. We're big enough to take it.

● Love

We can love ourselves. We can love every effort we make—the huge ones and the hopeless ones. We can love them as we love the efforts of a child. We can love the day we first teetered on high heels and the day our lipstick got stuck on our teeth. We can love the day our voice cracked and that first date when our heart pounded. We can love the failures and the hand that made them. We can love our disappointment and feel a little tenderness towards ourselves. We are human, after all. If we just love ourselves, it's easy to keep moving forward.

● Be Foolish

If we go too far in any direction, we find out what it is to go over the edge, and even where the edge is. We can go to the place we know won't work and do it anyway, just to see. We need that experience; it's the way we'll know what foolishness is. We might discover it has brilliance in it. There's no need to be too polite. We're here to explore something vital and to do something true.

● Courage

We must mention courage again here. Over and over in art—and life, too—we're asked to be bold and brave. With every drawing, we're asked: Can we go where we haven't been before? Will we try? Can we get out of our habitual mindset and allow the new? Can we trust in what we're doing? Whenever we feel bogged down, or like we're playing it safe, we'll feel the need for courage.

Fear is Imagining or expecting a negative outcome and feeling powerless. We can choose to imagine a positive outcome—this is how fear disappears. Courage is acting on that positive vision. Allow your thoughts only to be about what you want. Choose your highest vision. Forget everything else—all the messages from the past, the opinions of others, the things you've told yourself. All that only has power if we give it power.

We may feel anxious or uncertain, but that doesn't mean we should stop ourselves from going towards what calls us. If we hang back, we never feel satisfied—never feel we're on the adventure we want to be on. We limit ourselves.

The simplest way to find our courage is to act immediately on inspiration. Just do it. Just focus on the happy outcome and carry on.

In art, courage is going where we haven't gone before because something is calling us. Explore, make a mess, discover, and never be afraid. Just smile and do what you have to do. Leave the rest to the universe.

Michael Crockett—Amy (left); Jarad (right

24 The Confident Creative

"Action is the foundational key to all success."
—Picasso

• • • • •

In time, as we practice drawing and making art in whatever way we prefer, we come to a moment of discovery. This is who I am. It doesn't happen all at once, for the most part; it's a gradual awakening for most of us.

We begin to notice the qualities in our lines. When we become aware of being fully present, of letting go of all need to be "good," when we allow mistakes and messes, when we're willing to play without attachment to any one way—suddenly, there we are. We're there on the paper in front of us.

That funny, wiggly line is us, the dark, heavy stroke, the tender softness. We'll see what shows up. Perhaps it's a strong sense of design, or a sensitive rendering of nature, our ideas for social change, maybe a little humor, or a lot. This is who we are.

We see that now we draw in a bolder way than we thought possible. Our skills increase at a pace that surprises us when we lose our inhibitions and desire to please or get it "right." We see what our particular interests are. We know what we care most about, what we want to share with others.

But, most importantly, as we show up to draw day after day, we know how to slip into the space of presence. It becomes second nature, and we learn to trust this space. It's meditation, oneness, and it's there for us any time we choose it. We know this is where inspiration comes to us. And we sense now that this is the true creative self—the one that's aligned with the energy of the universe. We can access it whenever we like and be in the flow of creativity. We know that for any problem there's a solution, and that we can find it by opening up to inspiration. This is true confidence.

We know now how to work with the thoughts that dance through our minds and how to let them go, one by one, and return to what we're doing. We notice now when we reach the limit of our abilities and allow ourselves to inch forward into the place we haven't yet been able to go. We have learned not to force things, but to be kind to ourselves and move forward consciously.

When we go beyond the limitations of our ego minds and into the infinite mind of which we're all part, we meet the true creative self. We can learn to act immediately on

inspiration, without hesitation. We each have something unique to offer. We're co-creators, not only of our art but also of our lives and the world we live in—part of an infinite web. In creativity, we are co-creating with the Creator, not separate from that intelligence.

When we draw we may not think about these things, nor do we have to. We just need to sit down in good spirits and begin. Whether or not we do anything with the art we make only matters as far as our intention for it goes. The practice itself is liberating. Each time we sit down to draw, we can connect again with who we really are.

Yuko Adachi—The Universe Loves and Forgives

25 Keep Calm and Carry On!

"If you're going through hell, keep going."
—Winston Churchill

.

Sometimes the creative process can feel a bit like hell. We can be in the middle of a drawing or painting, or any other creative work, and wonder how it all might end or if it ever will. It may seem sometimes like everything's going wrong. It's the nature of the process. Even if it feels we're not getting anywhere, it's not true.

Several members of The Saturday Morning Drawing Club have faced discouragement. One woman was on the cusp of giving up when, suddenly, through some burst of determination, she shot into a whole new orbit in which her drawing had fresh boldness and confidence. Had she given up, she wouldn't have known what was just about to happen. As long as we feel the desire to draw and make art or do any other creative thing, no matter how discouraged we feel, we can keep calm and carry on.

There's no need to dwell on feeling discouraged, only to see it for what it is: a moment of uncertainty or confusion. Even when we encounter failure—and we will—we can just see what went wrong, let it go, and move on. Sometimes we might hope to sell our work in a gallery, and yet it seems that not a single gallery owner will even cast an eye our way. But we don't know the whole story, and we never will if we give up. Even when it seems hopeless, we'll carry on in the direction of our dreams.

Discouragement can feel overwhelming, like a black hole we trip into that sucks us down. But the truth is that if we hear a call, we have everything we need to answer it. Maybe we have to buy a new jacket or comb our hair, so that others can see us shine and so that we believe we can shine. Maybe our path changes direction. In that case, we keep our eyes open and reinvent as we go. We can also find friends on similar journeys to offer words of encouragement. We all need such friends, and we need to be such friends, too.

No matter what, we'll just keep going and put our best foot forward with a steady head. That's all.

A Club

"A dream you dream alone is only a dream.
A dream you dream together is reality."
—John Lennon

• • • • •

To make art is to set off on a journey that changes us. And when we rub shoulders with others doing creative work, the energy expands and we move forward more quickly. Working alone, we might grow a little weary.

We artists need to find others with whom to share the journey. Like attracts like. We can spot another artist 20 yards away on the platform in Grand Central Station, in the midst of a thousand people. We can spot an artist sitting alone in a café on a winter day, hunched over a hot cup of tea beside windows steamed with the breath of a hundred other patrons. We say hello. We find each other without much difficulty when we want to. When we ask, we'll find.

Almost as soon as we say we'd like to meet an artist, presto—one appears, possibly two or three, just like that. We go to a party or an art opening. We take a class at an art center, go to a reading in a bookstore, visit a museum, have a drink at a bar, swim in the ocean. Artists are everywhere. And more people are artists than we think—some are judges and teachers and carpenters, too.

We'll find friends who are on journeys similar to ours. One might work in thread, another in clay. One might be a little further along in terms of craft. Another might be lagging behind in terms of ideas, or struggling to make a living when we've found our way. We welcome all. We are sisters and brothers, family, fellow travelers. Our destinations may vary, but we've all boarded the train. Our pasts are individual, and so are our futures. We may have parallel paths, or our paths may intersect only for a time. Sometimes we

must go in opposite directions for a while but, with luck, we'll do so with a hug and good wishes; after all, we're still fellow travelers. These are precious friendships, ones in which we try to share the whole of ourselves as much as we can, ones that offer support and challenge.

Picasso had Matisse, and Matisse—Picasso. They were very different artists but equal in devotion. Together, they fueled each other's explorations and growth. Magic happens when artists talk about art—ideas arrive in the midst of chatting or looking at what we've each produced. We can inspire each other.

If we wonder how we might strengthen our practice, how we might gain courage and enjoy camaraderie, the idea of a club might well present itself—a drawing club. We can gather a few fellow artists. Some might just be embarking on their art journey; some might have been artists for many years in one way or another and seeking to make a quantum leap in their art. Some might spend all day working as artists; some might have other occupations. It doesn't matter. Anyone with a sincere desire to explore their own creativity through drawing can join. We can gather, perhaps on a Saturday morning, to draw together—at least for a while.

One great benefit of a drawing club is that we can find what is good in the work of our fellow artists and tell them. So often it's hard for us to see our own work clearly, but we can notice and affirm what's of interest in another's work. And they can do this for us. But the greatest gift of making art together—the one we discovered right away in The Saturday Morning Drawing Club—is how happy it makes you feel. When I began teaching this drawing class, I thought we'd all learn to draw with greater skill. What I didn't expect was the laughter and joy that drawing together produces. It's such a simple thing, just picking up a pencil and drawing together. Even alone, we can always come into that place of happiness just by drawing. When we work together, whatever happiness we create is amplified. This energy ripples out into the world, even if we toss our drawings into the bin at the end of the day.

27 Making Waves

"Success is going from failure to failure without a loss of enthusiasm."
—Winston Churchill

· · · · ·

The other day I attended open studios in Boston's South End. Everywhere I looked, there were signs on buildings saying "More studios here!" It felt like the whole city was crawling with artists—an amazing thought! Going from studio to studio, I saw all sorts of fantastic work and met artists at various stages of their development. I saw retirees just beginning their art journeys, so engaged in what they're doing that they splashed out on studio space. I saw kids just out of high school piled into a tiny studio together, drawing and painting. I saw professional artists, some with followings, who turned their studios into galleries for the weekend.

Some of the studios were in dilapidated buildings with worn wooden floors, peeling paint, and old toilet stalls in the hall. Others were in buildings renovated by savvy developers who know that when artists arrive in an undeveloped area of a city, it soon becomes desirable and chic. This area of Boston once was home to factories that manufactured who knows what; now great mill wheels sit outside the buildings as a sculptural tribute to that history. The area was desolate for 50 years; now, everywhere we look, another gallery has arrived, accompanied by another shop and restaurant.

Art and artists change cities. They make waves. Look at what happened in 2000, when the Tate Modern moved into the derelict Bankside Power Station on the South Bank of the River Thames in central London. The Tate Modern was intended for temporary exhibitions of contemporary art that could not be accommodated at the old Tate Gallery (now the Tate Britain) on Millbank. But so wildly popular has it been, it has now become the country's main national gallery of international modern art. A major new extension, due to open in 2012, is already under construction, with a price tag of approximately £215 million. The Tate Modern now attracts 5 million visitors a year and the number is growing.

The planet is in peril; environmental and political challenges abound. It's tempting to indulge in doomsday talk yet, everywhere we look, something else is happening too—consciousness is expanding. People everywhere are seeking to express themselves in visual, tangible, creative, and honest ways. Old people and young people, and everyone in

Julia Talcott

between. People are making jewelry and pottery, handbags, scarves, and clothes for sale. They're writing and making music and films. They're taking photographs. They're opening farmers' markets and restaurants with healthy food. Many are creating ethical businesses with the intention of offering quality merchandise or services at fair prices. There are many ways to bring our true creativity into the world.

Artists are making prints and paintings and sculptures and drawings and photographs. Some of this art is for the public. Still others are making installations of such an esoteric nature that there's little chance to sell the work, yet galleries are showing it anyway. Artists are taking the issues that face the planet and bringing attention to these issues through their art. Some are even envisioning solutions. Other art is more personal—the artist intends it for his or her own walls, or for family and friends. Some artists simply draw for the transformative pleasure of being fully present where they are. They know that presence brings peace. And we're beginning to see that we can only create peace in this world when we find it first in ourselves. That is when we see that we are all one, no matter our color, our beliefs, our stripes. Art is transformation.

If, when we draw, we can bring awareness to what we're doing and to our thoughts, the practice of drawing changes who we are, the way we see, and what we create in our art and in our lives. It asks challenging things of us: that we never avert our eyes, that we tell the truth as we see it, and that we be ourselves. It asks us to have the courage to go where we haven't been before. And it teaches us to be humble, to let go of control, and to receive the inspiration that comes to us and to act on it immediately, without hesitation.

I hope, that in the future, visual thinking and art making will be a more vital part of every child's educational development, so that no one need lose touch with the creative side of themselves, or with careful observation and appreciation of the world around them. We need creative thinkers to create a new world. My wish is that we may all know the way art can open us to inspiration and positive action. Then we can be co-creators of our own lives and of life on our planet.

And, now, back to the drawing board! The world is waiting. And it needs us.

 Appendix 1: Making Marks

Experiment with materials, as well as different kinds of marks. This is our chance to really play and be free. There is no right or wrong. It's very important to give ourselves the opportunity to experiment in all sorts of ways. This is also a great meditative practice. Afterwards, you can cut up some of your mark drawings and make a collage, if you like. Return to mark making whenever you feel stuck—it frees the hand and the mind.

Experiment with drawing implements:

1. Pencils. They come in different degrees of hard and soft. "H" is for hard and will give a very fine, sharp line. "B" is for soft and will give a darker line. "4H" is harder than "H." "2B" is softer than "B." Try a few different pencils.

2. Charcoal. It comes in twig sticks and short block sticks. The twigs are lighter and grey-black like carbon; the block sticks are black like coal. They come in soft and hard. Softer is blacker; harder gives a sharper line. We can smudge charcoal and get great tones.

3. Roller pens. These come in different points: fine, medium, wide. They glide easily over the paper and come in different colors.

4. Ballpoint pens. They also come in different widths and colors and glide easily over paper.

5. Crow-quill pen and India ink. The nibs come in various widths from very fine to thick, flat calligraphy nibs. Stiff, inflexible nibs make firm lines. Flexible nibs make lines that vary in width according to how hard we press. India or drawing ink is waterproof, so once the line is drawn it's permanent and won't smudge. We can paint over with watercolor.

6. Brush and ink. We can use watercolor or Chinese calligraphy brushes that come in different widths.

7. Fingers covered in charcoal dust.

8. Twigs dipped in thinned poster paint or ink.

9. Crayons.

10. The computer. If you have a vector-based computer drawing program, you can draw on a tablet, or with the mouse, and have it appear on your monitor.

Experiment with papers:

1. Newsprint. Cheap and excellent for charcoal.

2. Ordinary computer or copy paper. Also cheap and excellent for pencil, roller pens, ballpoint pens, and crow-quill pens.

3. Drawing paper. Acid-free paper is best for drawings you wish to preserve. For drawing

practice, any kind of drawing paper will do. Use a thicker paper for wet mediums like ink and watercolor. Paper with a tooth is best for charcoal and pastels.

4. Brown paper. Cheap paper that offers the chance to draw on a shaded stock. If we draw in black, we can try adding highlights in white chalk if we're using charcoal, or watercolor if we're using ink.

5. Rice paper. Traditional for Chinese brush drawing with ink.

6. Tracing paper. Good for planning and for imaginative drawing with pencil or ballpoint or roller pen. We can place a sheet on top of a completed drawing and alter it by tracing over and making changes.

Experiment with marks:

1. Lines like ocean waves

2. Lines like rain

3. Lines thick as clouds

4. Lines thin as thread

5. Lines round like buttons

6. Lines jagged as craggy rocks

7. Lines like dots of snow

8. Lines like threads dotted with snow

9. Lines like the rings of Saturn

10. Lines like the stars shining at night

A few specific experiments to try:

1. A still line floating in space

2. A line broken as a heart can be

3. A line made whole again

4. One line that tells the story of your life

5. Two lines that tell the story of your mother and you

6. Two lines in two different colors

7. One hundred lines that whisper of your hope for the planet

8. One hundred lines that express the fullness of your heart

9. A pattern of lines and smudges, of starts and stops

10. Two lines meeting

 Appendix 2: Drawing What We See

We can draw anything. Something with a shape as simple as a sweet potato will be rich in texture, light, and shadow. Something familiar, such as our old silk slipper with its frayed toe, might surprise us with the emotions it evokes. Or perhaps we're drawn to a man in a hat at the local café. Begin to notice what it is you most want to explore. Notice whether your approach is a careful, sensitive engagement with the world around you, or perhaps a quick, lively impression. There are many ways to draw what we see; our drawings will reflect who we are. Enjoy.

Try this:

1. Set up a still life with fruits and vegetables you have in the fridge. Draw it in charcoal, then in color.

2. Find kitchen implements and utensils to draw—an egg beater, a wire whisk, a spatula, a fork, a knife, a spoon. Draw them separately, then make an arrangement and draw them together. Make a contour drawing and focus on where you're headed. Allow your eyes to look ahead to where you're going; the hand will follow.

4. Go to a café and draw the clientele. Draw fast, so they don't notice. Use line only. We can make several drawings on one page. People will move around, so we need to work fast.

5. Take digital photographs of people on the street. Look for and notice what interests you. When you get home, print them out and draw from them. This is a great way to observe your world with more care.

6. Sit on a park bench and draw the landscape. Cut a small square in a piece of paper and hold it up to one eye to frame the view and compose your picture. Think about how you'll distill all this information into a few simple lines. Draw quickly, then try drawing more slowly.

7. Draw a wooden chair. This will give you some experience drawing perspective. You can look up information about perspective drawing in books or online. Find the vanishing point.

8. Draw a building, maybe your house.

9. Draw a hat your grandfather wore, the necklace you wore when you went to that fancy dance, the rubber duck your little boy plays with in the bath. Objects with emotional content will encourage expressive drawing.

10. Draw your cat. Use pastels and add shading. Add detail like fine strokes for the fur over the shading.

11. Draw your friend sitting across from you, reading. Use colored pencils. Look at how

David Hockney did this.

12. Draw your friend lying on the sofa, asleep. Use pencil and transparent watercolor. Then try gouache, opaque watercolor. Which expresses your vision best?

13. Draw a naked body. Check art centers for life-drawing classes or open-studio times. At many centers, you can pay a small fee to spend a few hours drawing from a model.

14. Find photographs of famous people in magazines and draw them.

15. Draw from photographs of people in magazines who are not famous. Do you notice any difference when you draw famous and not famous people? Are your expectations different?

16. Draw yourself. Set up a small mirror and draw yourself using contour drawing, then try drawing yourself using dark and light. Are you willing to draw yourself just as you are? Are you willing to leave in those fine wrinkle lines between the brow or your messy hair? Sometimes, drawing makes us aware of our desire to make ourselves look good.

17. Draw the plants in your house, one by one. Do them in color.

18. Draw the clouds in the sky.

19. Collect leaves from trees and draw them with silver metallic pen on black paper. What kind of quality does this lend them?

20. Draw a face with metallic pen on black paper.

21. Draw a face with black charcoal on tan paper and add highlight with white pastel.

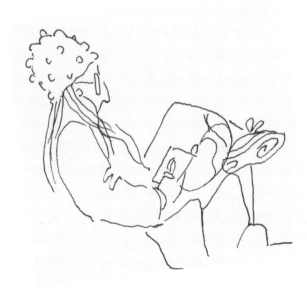

Julia Talcott—from sketchbook

 Appendix 3: Drawing from Imagination

Draw all sorts of things, whatever comes to mind. See the ways you can begin to think in a conceptual way with clear intention up front. Think about what you want to communicate. Explore several ways of saying the same thing. Ideas will also come in the process of drawing and exploring. Keep an open mind and a willingness to experiment and play. Notice what comes up for you and keep going!

Try this:

1. Make a list of objects—shoe, cup, hat, coat, tomato, fly, car, building, etcetera, and draw them in pen. When we use pen we can't erase, so resist the urge to make things "perfect." Imaginative drawing develops through constant practice.

2 Clarify and simplify. Look at your drawings and begin to get a take on your style. Are your lines wavy or slick? Are your characters realistic, cartoonlike, or stylized? Are your drawings simple contour drawings, or do you use shading? You can heighten your style by clarifying and simplifying.

3. Draw a one-page comic strip. Invent a character and a story.

4. Draw the Eiffel Tower of your imagination. What is the structure? What is it made of?

5. Design your ideal home. What does home mean to you? What might your ideal home provide that a normal living space doesn't?

6. Design an ephemeral art project, one that isn't meant to last. Perhaps a chalk drawing on an outdoor sidewalk or a personal performance piece. What is the purpose? What might it look like? We can use imaginative drawing to get ideas and map them out.

7. Design a jacket and decorate it with drawings.

8. Design a poster that reflects a deep conviction. If you don't know what you want to do, write and draw until you begin to uncover it.

9. Draw an imaginary landscape.

10. Draw a portrait of yourself without looking. Now look and do an observational drawing of yourself. Then draw yourself again without looking.

11. Draw what you'd like for dinner.

12. Draw an elephant. Notice the limitations to your knowledge. Find a photo of an elephant and compare. Look at how Jean de Brunhoff drew Babar. Draw another elephant.

13. Draw a Dada picture. Cut out a photograph and draw something over it that gives it new meaning. Make a line drawing and paste on bits of found photographs.

14. Get a huge piece of white drawing paper and draw portraits of your friends from mem-

ory. The paper is expensive, worthy of friends. Don't be afraid of it. Paste their photographs beside your drawings.

15. Sketch out a poster for world peace. Do you not know how to begin? How will you get ideas? What might symbolize peace in an original way? Do a few sketches and explore different ideas. The more we do, the more ideas we get. Keep going until you get one you love.

16. Draw a prayer flag to string across Wall Street. What will it say?

17. Draw on a wooden chair. What will you have people sit on?

18. Draw a flowering plant. Make up the blossoms and color them.

19. Draw a map of your heart. What's in it?

20. Listen to music and draw whatever comes to mind.

Acknowledgements . . .

The idea for this book came in fledgling form before I began to teach. I saw how artists struggled with their creative work from time to time, as I too had done. To me the journey progresses in stages and I wondered if we might leap with more ease into our true creative power if we had more awareness of the process. At the time, my husband, Allan Hunter, was writing about the six archetypal stages of human development in his book *Stories We Need To Know* and this sparked ideas about the creative journey of artists. Just as the ideas began to take form, I was invited to teach drawing at The Arsenal Center for the Arts just outside Boston. Whatever I might have written before I began to teach was amplified by the bold, brave steps my students took. And so, the thanks are many—

First, to Allan, for his love, unwavering support and for meeting my every wild exploration with curiosity, a prodigious intellect and keen insight.

To my bambini, Anna and Nick Portnoy, who greet the world with humor and kindness, thanks for being such enlivening companions and especially for help with the title. To my late father, Charles, my mother, Billie, and brother Grant—thanks for love and laughter.

Thanks to Beverly Snow, Program Director at The Arsenal Center for the Arts, who hired me to teach, and whose good humored support helped launch the class. Also to Martin Holbrook and Dawn Scaltreto for their help and welcome when I arrived as a studio artist at the Center. The Arsenal Center for the Arts in Watertown, MA has given artists fertile ground from which to make quantum leaps. Thanks to all who worked so hard on its creation.

To Sally Young, Connie Henry, Maureen Cook, Maggie Stern, Barbara Epstein, Carole Katz, Kathy Manley, Maggie Mattson, Barbara Neel, Margaret Metzger, Lyn Anger-meier Carr, Maude Bigelow, Deb Kaup, Mimi Treslow, Sue Twombly, Judy Kamm and all the members of the drawing class who have stepped into brave new creative worlds and who prove every Saturday the transcendent art of laughter. A special thanks to those who were in the class at the time I was assembling the book for contributing samples of their work.

Special thanks to Sally Young and Connie Henry who first envisioned the drawing class, invited me to teach it and corralled the first students into it.

Some years before, when Sally staged an annual art salon, she offered me a show which changed the direction of my work. For acting without hesitation upon inspiration

and being a creative magician of life, deep thanks.

To Mark Peterson, for so generously offering his excellent photographic skills, good cheer and kind support.

To Nicky Leach, my editor, whose astute and wise perceptions sharpened the text and whose timely return of the corrected manuscript made the process a smooth one.

To Matt Jatkola, graphic designer and musician, for patient, insightful assistance and for a sharp eye. And to Caryl Hull, of Hull Creative Group, for generous and creative graphic design advice.

To the beautiful artists, not in the class, who all agreed, without hesitation, to be in this book—Yuko Adachi, Aparna Agrawal, Michael Crockett, Laura Douglass, Katherine Dunn, Caroline Leaf, Julia Talcott, Kathy Todd, Deborah Putnoi, Susy Pilgrim Waters, and Kaetlyn Wilcox—I know others will be as inspired by your work as I am.

To Koei Kuwahara, acupuncturist and Akido master, I will be forever grateful for everything he taught me about creating positive energy in the world.

Deep gratitude to Thierry Bogliolo, the publisher of Findhorn Press, whose immediate yes, warm support and trust have made the process of creating this book a deeply happy one. Thanks also to his staff for backing him up on Findhorn's first art book.

Finally, thanks to you, the reader, for considering all the ways you will bring your positive, creative energy into the world. Life is art!

Credits . . .

Contributing Artists—

To see their work and learn more about them, please visit their websites.

Yuko Adachi—www.yukoadachi.com

Aparna Agrawal—www.aparnaart.net

Cat Bennett—www.catbennett.net

Michael Crockett—www.facebook.com/hazeleyesstudio

Laura Douglass—www.yogapsychology.org

Katherine Dunn—www.katherinedunn.us

Caroline Leaf—www.carolineleaf.com

Susy Pilgrim Waters—www.pilgrimwaters.com

Deborah Putnoi—www.deborahputnoi.com

Julia Talcott—www.juliatalcott.com

Kathy Todd—www.kathytodd.co.uk

Kaetlyn Wilcox—web.mac.com/kaetlynwilcox

Contributing Members of The Saturday Morning Drawing Club—

Lyn Angermeier Carr (www.lynfineart.net), Maude Bigelow, Maureen Cook, Connie Henry, Carole Katz, Maggie Stern (www.maggiestern.com), Margaret Metzger, Sue Twombly and Sally Young

Introduction Artists—

The mischievous self-portrait was left behind after a kid's art class and signed Lizzie. Full credit will be given in future editions when we discover her last name. The drawing of the monkey is by Eva Henry, aged six.

All unattributed art: Cat Bennett

Photography—

Mark Peterson—www.siteandsituation.com

Graphic Designer—Matt Jatkola

Art Director—Cat Bennett

Editor—Nicky Leach

Publishing Director—Thierry Bogliolo/Findhorn Press

FINDHORN PRESS

Life changing books

For a complete catalogue,
please contact:

Findhorn Press Ltd
305a The Park
Findhorn, Forres IV36 3TE
Scotland, UK
t +44(0)1309 690582
f +44(0)131 777 2711
e info@findhornpress.com

or consult our catalogue online
(with secure order facility) on
www.findhornpress.com

For information on the Findhorn Foundation:
www.findhorn.org